# *Remembering* Pennsylvania

Laura E. Beardsley

TURNER
PUBLISHING COMPANY

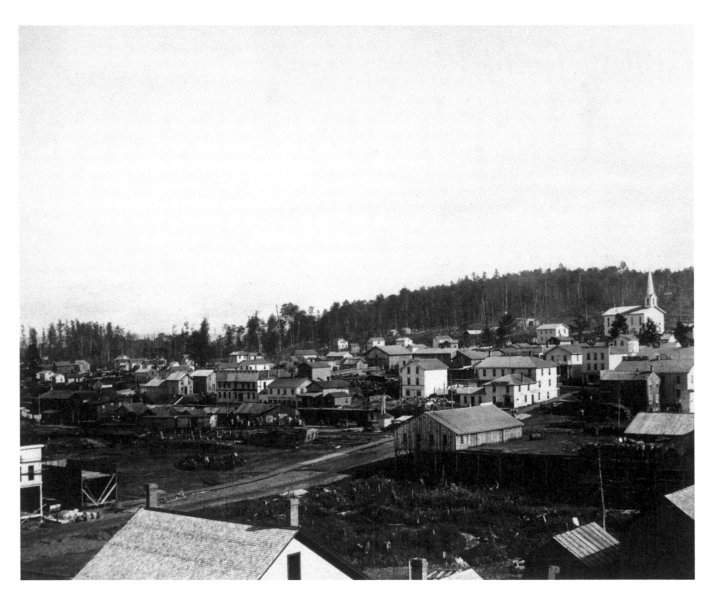

Williamsport, known in the nineteenth century as the "lumber capital of the world," reputedly had more millionaires per capita than any town in the country. Seen here at its peak at the end of the 1800s, Williamsport became the birthplace of Little League baseball in 1939.

*Remembering*

# Pennsylvania

Turner Publishing Company
4507 Charlotte Avenue, Suite 100
Nashville, TN 37209
(615) 255-2665

*Remembering Pennsylvania*

www.turnerpublishing.com

Copyright © 2010 Turner Publishing Company

Library of Congress Control Number: 2010932638

ISBN: 978-1-59652-712-6

Printed in the United States of America

ISBN: 978-1-68336-871-7 (pbk)

10 11 12 13 14 15 16—0 9 8 7 6 5 4 3 2

# CONTENTS

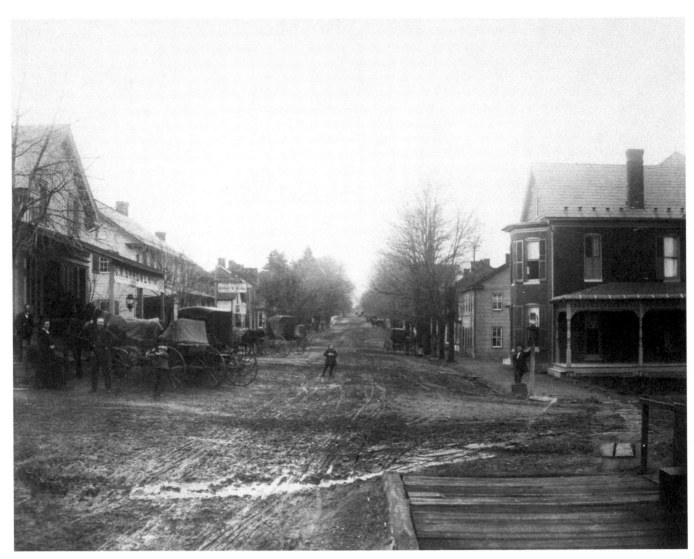

Local residents pose at the intersection of the Gettysburg and Harrisburg roads in York Springs, Adams County.

# ACKNOWLEDGMENTS

This volume, *Remembering Pennsylvania,* is the result of the cooperation and efforts of many individuals, organizations, and corporations. It is with great thanks that we acknowledge the valuable contribution of the following for their generous support:

Hershey Community Archives, Hershey, Pa.
Library and Archives Division, Sen. John Heinz History Center
Library of Congress
Temple University Libraries, Urban Archives, Philadelphia, Pa.
The Historical Society of Pennsylvania

# PREFACE

Pennsylvania has thousands of historic photographs that reside in archives, both locally and nationally. This book began with the observation that, while those photographs are of great interest to many, they are not easily accessible. During a time when Pennsylvania is looking ahead and evaluating its future course, many people are asking, How do we treat the past? These decisions affect every aspect of the state—architecture, public spaces, commerce, infrastructure—and these, in turn, affect the way that people live their lives. This book seeks to provide easy access to a valuable, objective look into the history of Pennsylvania.

The power of photographs is that they are less subjective than words in their treatment of history. Although the photographer can make subjective decisions regarding subject matter and how to capture and present it, photographs seldom interpret the past to the extent textual histories can. For this reason, photography is uniquely positioned to offer an original, untainted look at the past, allowing the viewer to learn for himself what the world was like a century or more ago.

This project represents countless hours of review and research. The researchers and writer have reviewed thousands of photographs in numerous archives. We greatly appreciate the generous assistance of the organizations listed in the acknowledgments of this work, without whom this project could not have been completed.

The goal in publishing this work is to provide broader access to this set of extraordinary photographs that seek to inspire, provide perspective, and evoke insight that might assist people who are responsible for determining Pennsylvania's future. In addition, the book seeks to preserve the past with adequate respect and reverence.

With the exception of touching up imperfections that have accrued with the passage of time and cropping where necessary, no changes have been made. The focus and clarity of many images are limited to the technology and the ability of the photographer at the time they were recorded.

The work is divided into eras. Beginning with some of the earliest known photographs of Pennsylvania, the first section records photographs through the end of the nineteenth century. The second section spans the beginning of the twentieth century through World War I. Section Three moves from the 1920s through the 1940s. The last section covers the 1950s to recent times.

In each of these sections we have made an effort to capture various aspects of life through our selection of photographs. People, commerce, transportation, infrastructure, religious institutions, and educational institutions have been included to provide a broad perspective.

We encourage readers to reflect as they go walking in Pennsylvania, strolling through its parks, its countryside, and the neighborhoods of its cities. It is the publisher's hope that in utilizing this work, longtime residents will learn something new and that new residents will gain a perspective on where Pennsylvania has been, so that each can contribute to its future.

*—Todd Bottorff, Publisher*

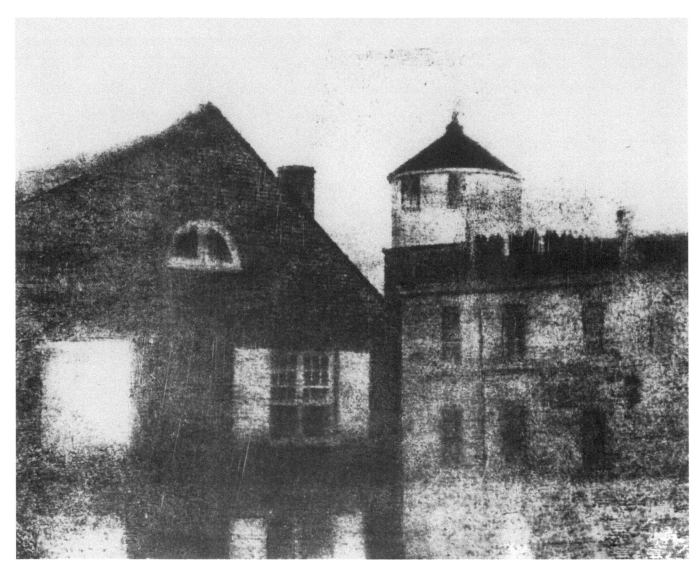

This unique view of Philadelphia's Central High School taken from a window of the United States Mint on September 25, 1839, is the oldest known photograph created in the United States. Amateur photographer and inventor Joseph Saxton created this daguerreotype after reading a brief description of the new photographic process in a local newspaper.

# Birthplace of Greatness

## (1859–1899)

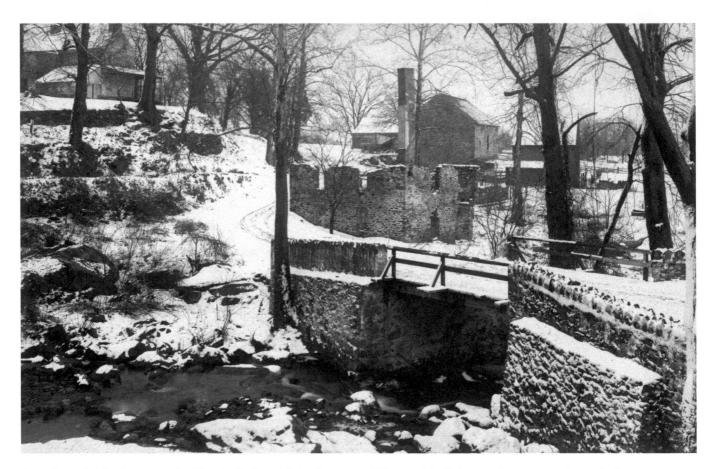

Sparsely settled by farmers and millers in the late 1600s, the town of Norwood in Delaware County grew into a bedroom community by the late 1870s. Connected to Philadelphia by an expanding freight and commuter railroad system, the town retained many features from its past, including the old mill seen here around 1860.

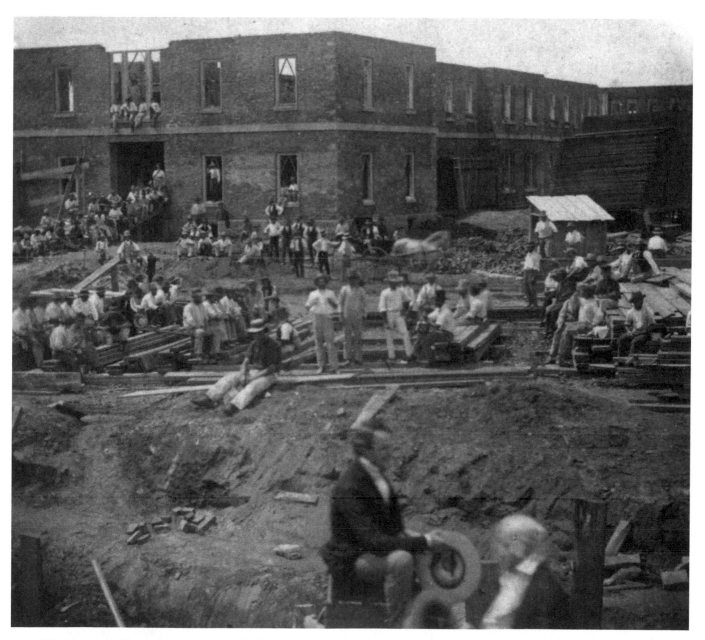

Workers pause for a photograph while building the Pennsylvania Hospital for the Insane in West Philadelphia, around 1859. Also known as Kirkbride's Hospital after director Thomas Kirkbride, it was known for its innovative, humane treatment of the mentally ill.

The Reverend Jehu Curtis Clay stands among the graves in the churchyard of Old Swedes (Gloria Dei) Church in Philadelphia around 1860. Built in 1700 by descendants of early Swedish missionaries and still an active Episcopal congregation, the church is the oldest in Pennsylvania.

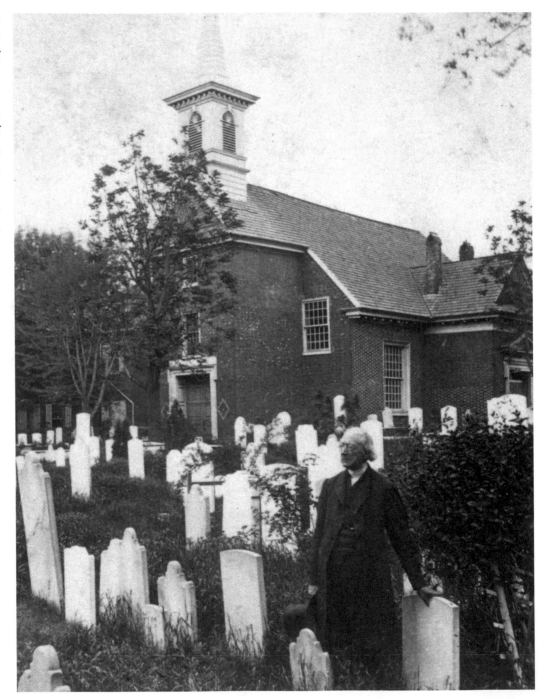

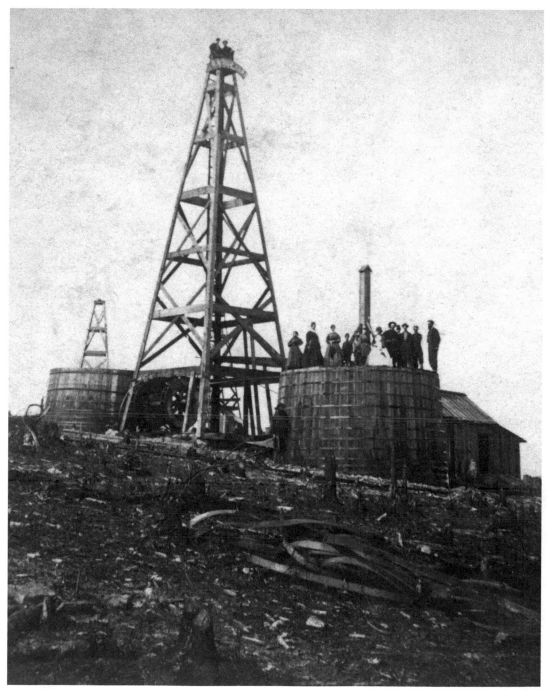

After oil wells were first successfully drilled in northwest Pennsylvania in the late 1850s, hundreds of individual oil derricks like this one were built by prospectors hoping to strike it rich. Pennsylvania would ultimately supply half of the world's oil before the Texas oil boom in 1901.

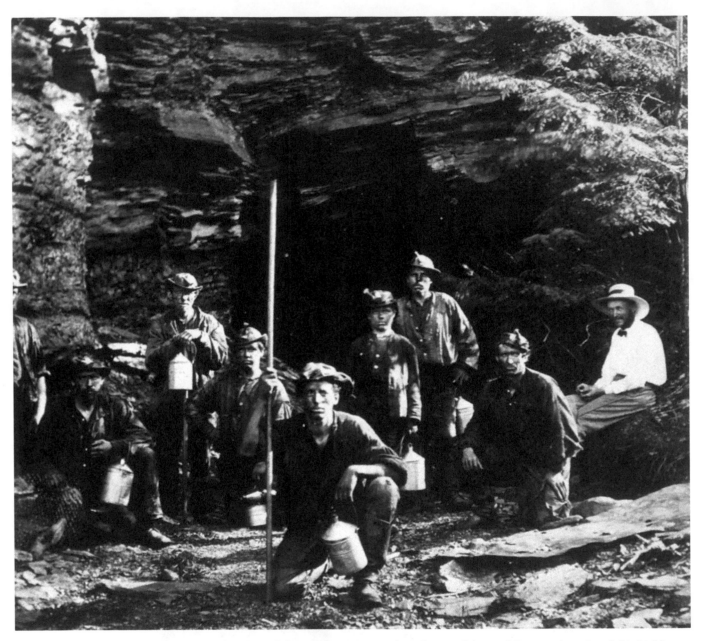

Anthracite coal was not successfully marketed until the mid-1800s, even though one of the world's great deposits of this highly efficient "hard" coal is found in the eastern and northeastern counties of the state. Photographed at the entrance to a natural cave, these men and boys in the Wyoming Valley illustrate how difficult early mining could be.

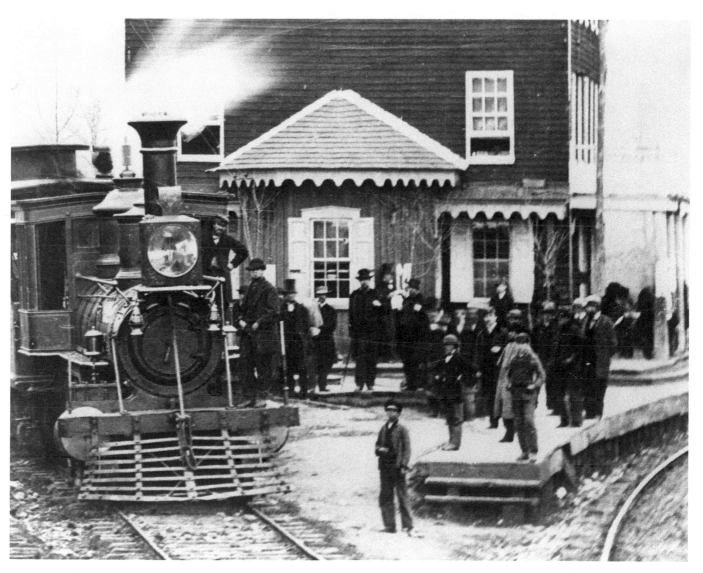

In November of 1863, Abraham Lincoln and a large number of dignitaries passed through Hanover Junction in York County on their way to and from Gettysburg, where Lincoln gave his famous address. It is believed that this photograph credited to Mathew Brady or his assistant documents one of those visits.

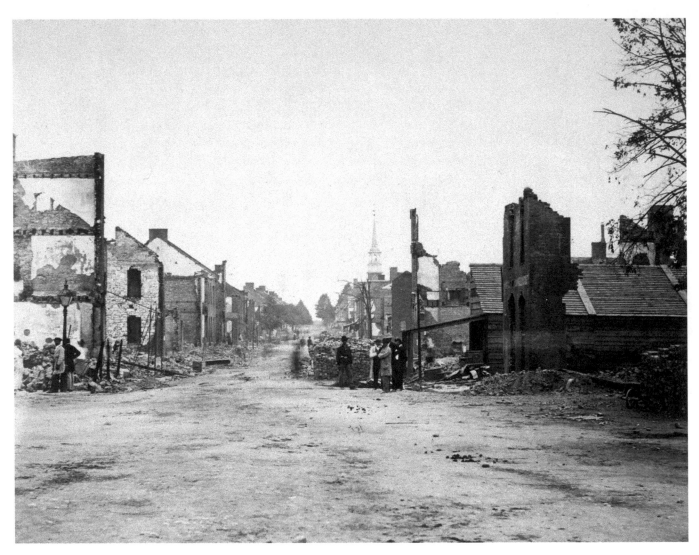

While the conflict at Gettysburg retains the most prominent place in modern memory, Chambersburg, just 16 miles north of the Mason-Dixon Line, was attacked and occupied by Southern forces three times during the Civil War. It recovered and remains today an active small town.

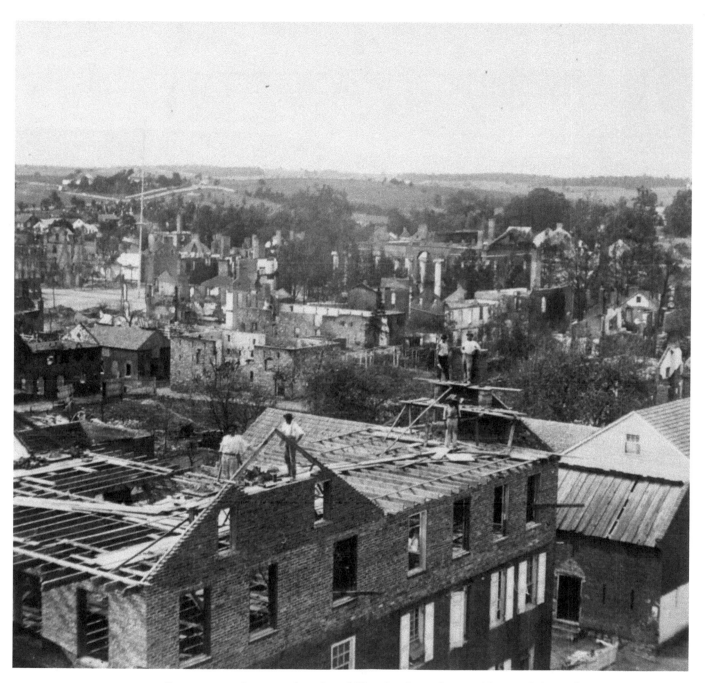

Carpenters work among the ruins of Chambersburg, destroyed by Confederate forces in July of 1864.

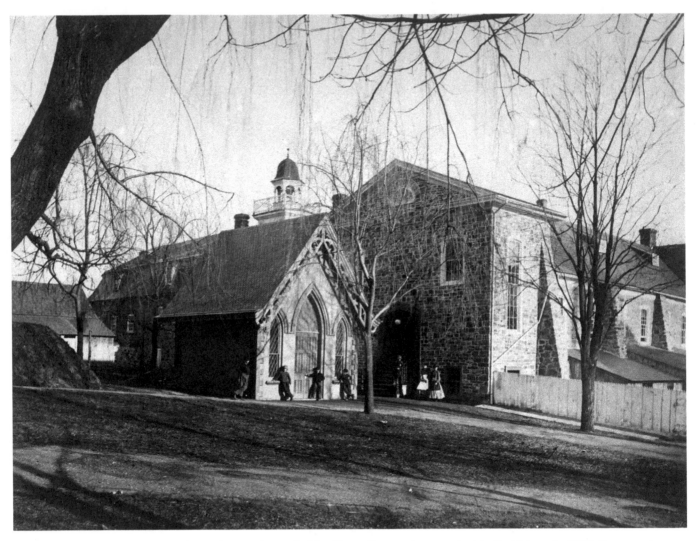

The Moravian Chapel, on the right, and its Gothic-style "dead house" were photographed in Bethlehem in 1866. In a practice characteristic to the Moravian sect, the deceased were placed in a dead house and guarded by the pallbearers while services were held in the chapel.

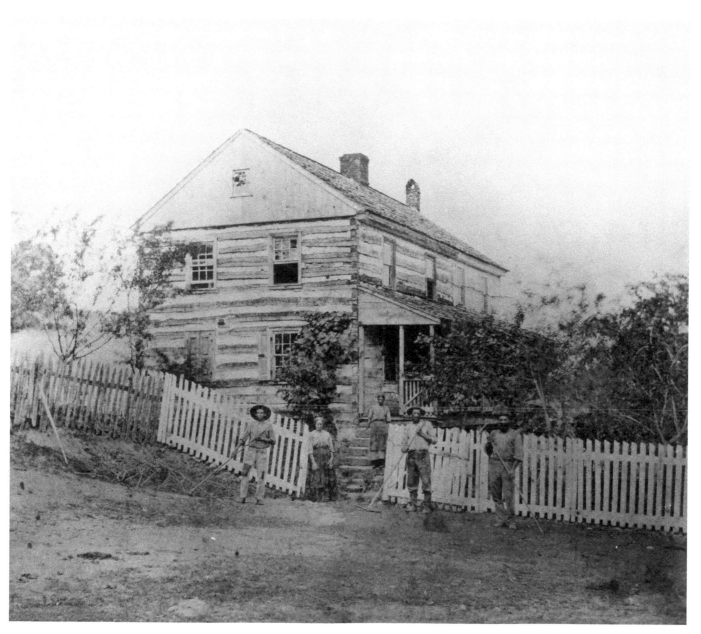

A family poses in front of their log house on Welsh Mountain in Lancaster County (ca. 1870).

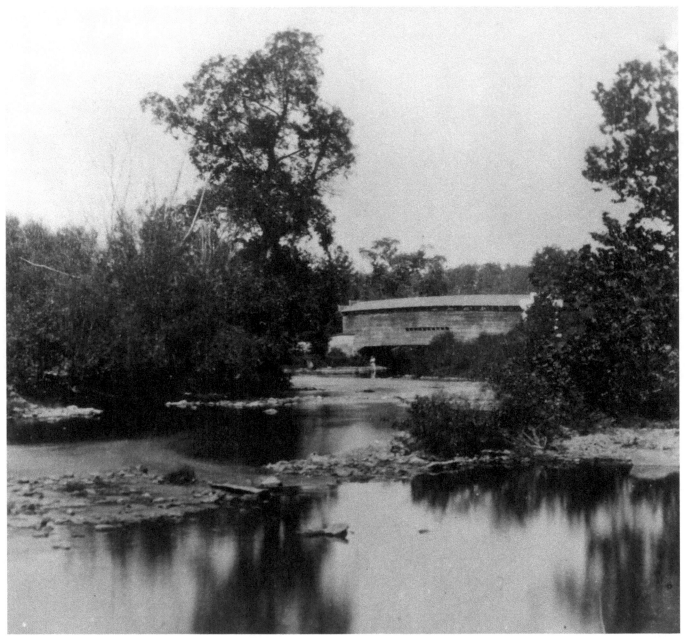

The Kennedy Covered Bridge, spanning the French Creek in Chester County, was built in 1856 and is seen here around 1870. The bridge was destroyed by fire in 1985, and a replica was constructed on the site three years later.

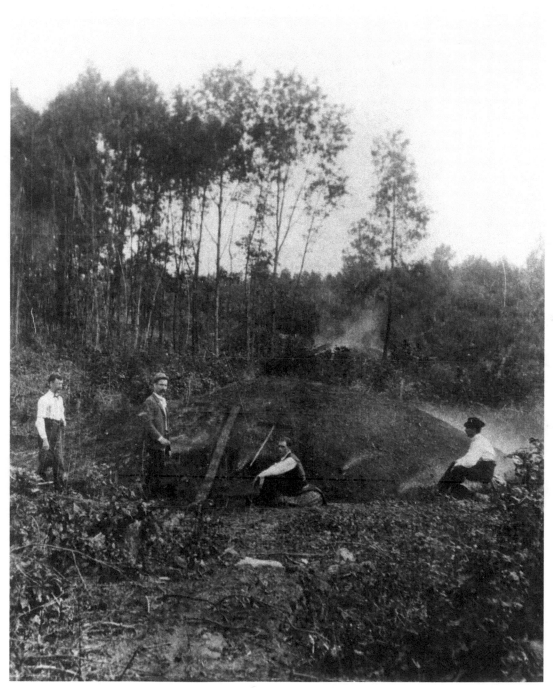

A crew of four men attends a large, mounded charcoal burner in the Hopewell Furnace region (ca. 1870). Charcoal was necessary in the cold-blast iron industry and was often produced by itinerants able to follow the wood-cutting crews in search of timber.

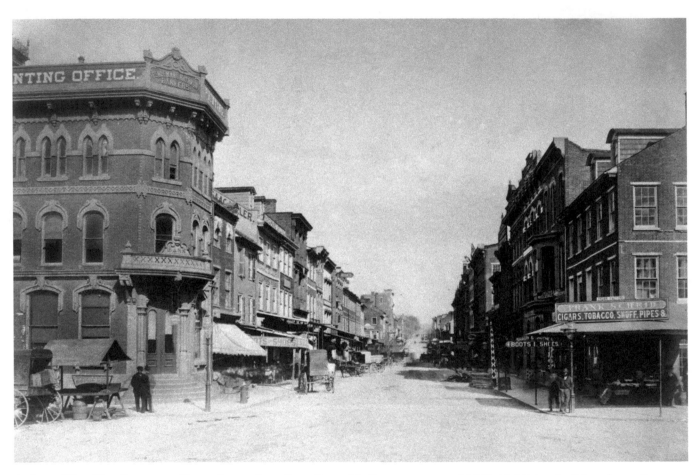

A view of East King Street near Center Square (now Penn Square) in Lancaster, around 1875, highlights the "cigar factory" business of Frank Scheid.

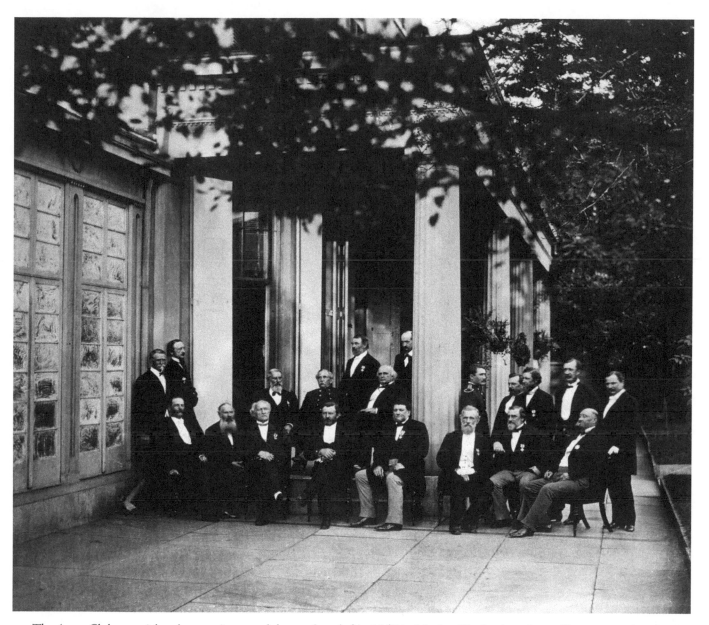

The Aztec Club, a social and entertainment club, was founded in 1847 in Mexico City by American officers occupying the city during the Mexican War. In this photo, members of the club are photographed at an anniversary dinner held at the home of General Robert Patterson, at Thirteenth and Locust streets in Philadelphia, in 1873. President Ulysses S. Grant is seated in the front row, fourth from the left.

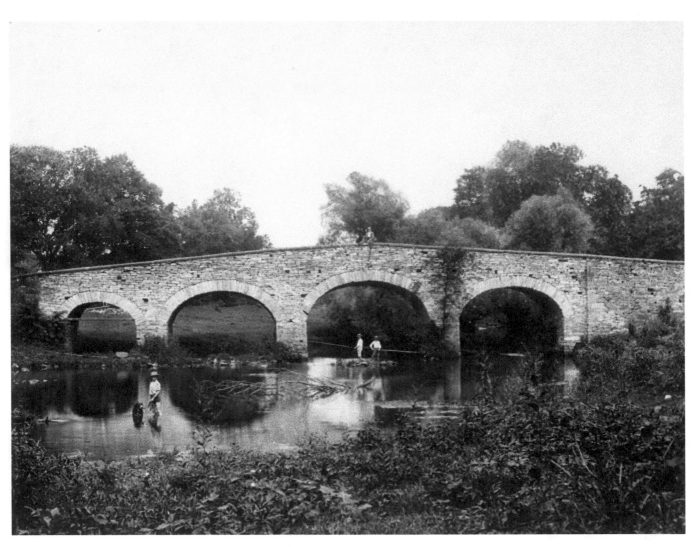

An old stone bridge on Cocalico Creek near Ephrata provides an ideal fishing spot in the 1870s.

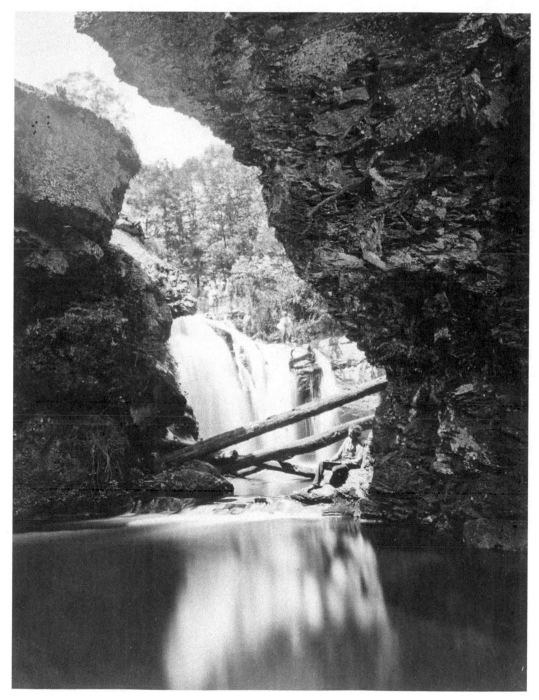

A hiker enjoys a secluded waterfall in Delaware Water Gap, along the boundary between Pennsylvania and New Jersey. By the latter half of the nineteenth century, the Delaware Water Gap region was a well-established summer resort area.

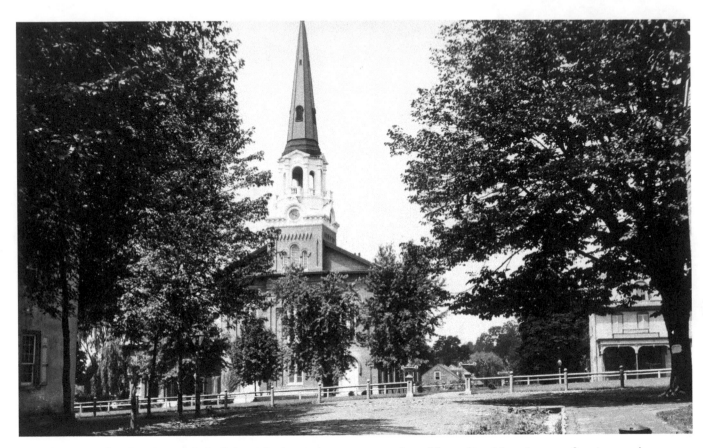

The Moravian Church in Nazareth, built in 1861, is seen here some years later. The earliest Moravians, a reformist sect that predated Martin Luther by 100 years, arrived in America in 1740 and temporarily settled in Nazareth. Within a year, they relocated to Bethlehem, which today serves as the Moravian Church's headquarters.

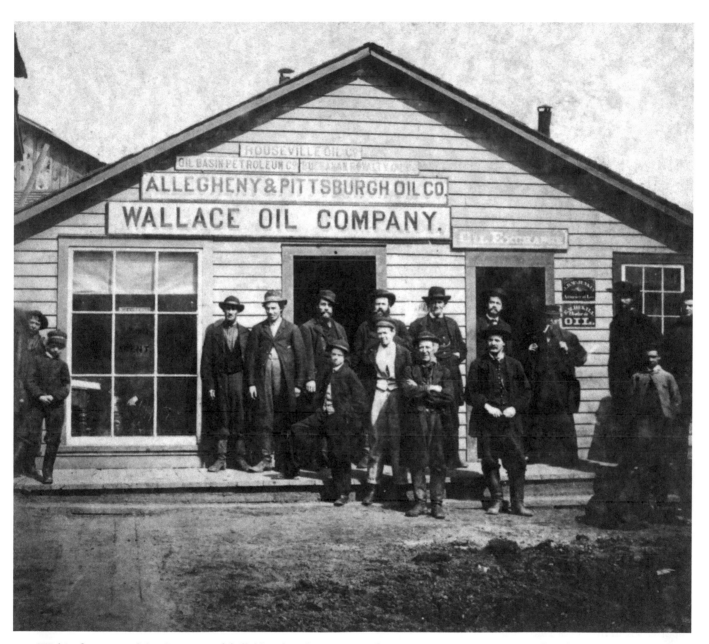

Within five years of the discovery of drillable oil in the counties of western Pennsylvania in 1859, hundreds of individual wells and small companies sprang up. Founded within a few months of each other in 1864, four oil companies share a headquarters in Rouseville, Venango County, a decade after the Civil War.

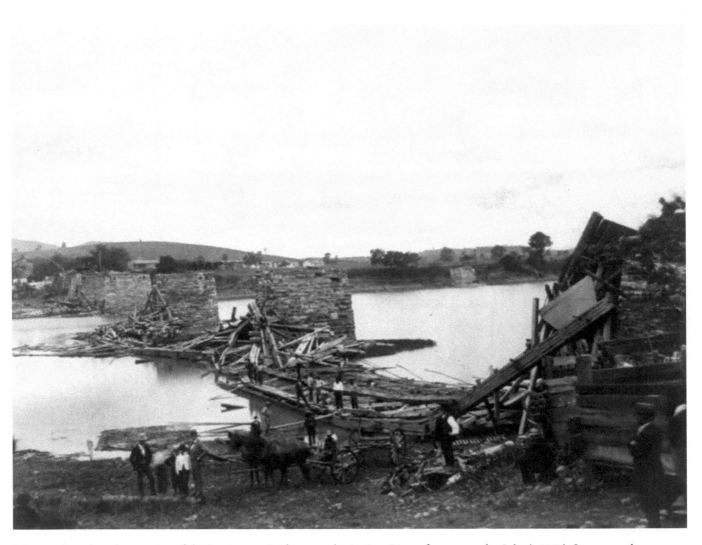

Men work to clear the remains of the Lewistown Bridge over the Juniata River after a tornado, July 4, 1874. Seven people were reported killed by the tornado, including three who were on this bridge or under it.

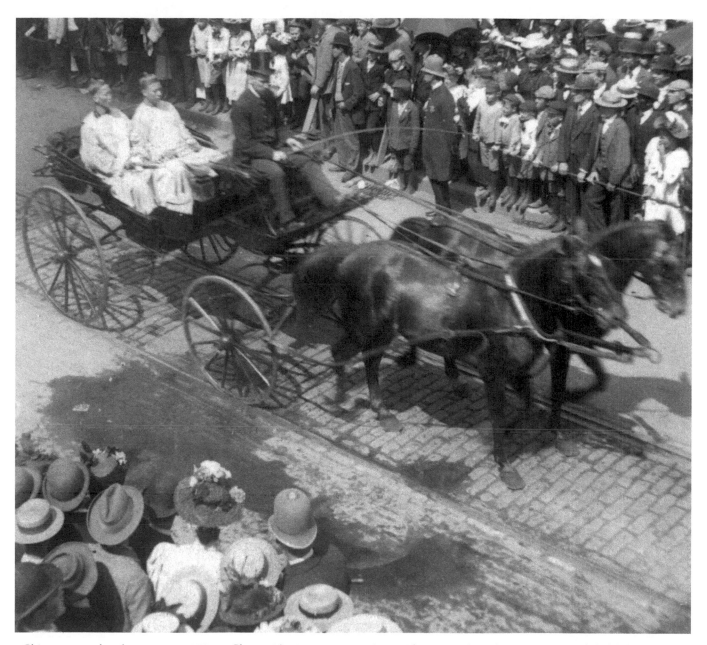

Chinese general and statesman Li Hung Chang rides in an open carriage with an attendant during a visit to Philadelphia in 1896. His visit to several American cities was an opportunity to advocate for changes in the anti–Chinese immigration laws passed in the 1880s.

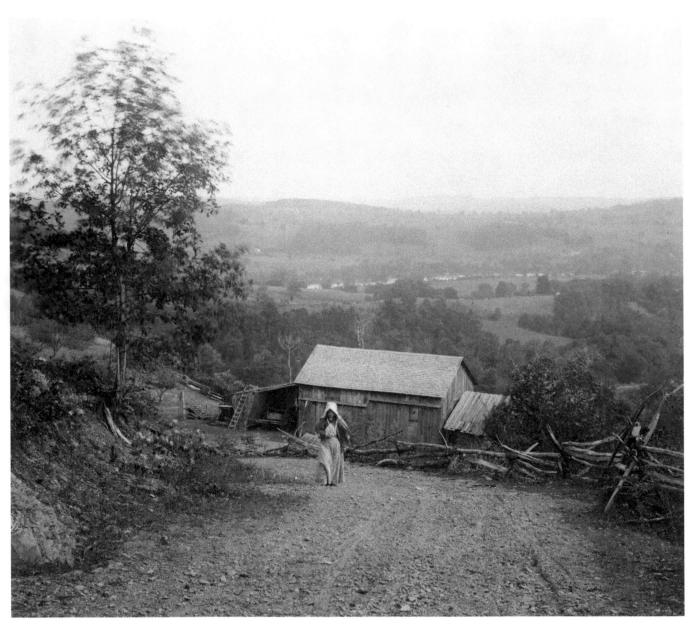

A woman walks up a valley road at Dingmans Ferry, Pike County (ca. 1897).

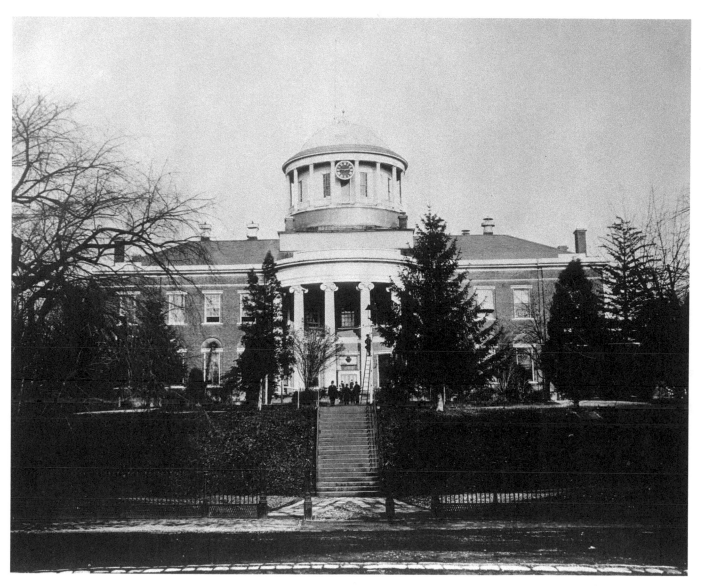

When the state seat of government was moved from Lancaster to Harrisburg in 1812, two fireproof capitol buildings were built to house the various state offices. Unfortunately (and perhaps ironically), in February of 1897 the main building seen here was lost to fire. The current Capitol was completed in 1906.

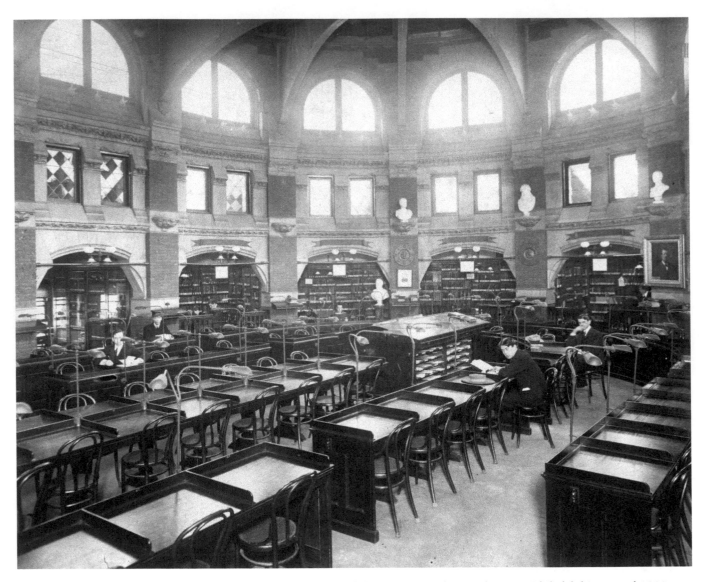

Students study in the reading room of the Victorian-era library of the University of Pennsylvania in Philadelphia around 1900. Designed by Frank Furness, the building represented a researched, practical approach to library design and use. By the 1960s the building was threatened with demolition, but has since undergone a complete restoration and is used as a fine arts library for the university.

# AN INDUSTRIAL POWER

## (1900–1919)

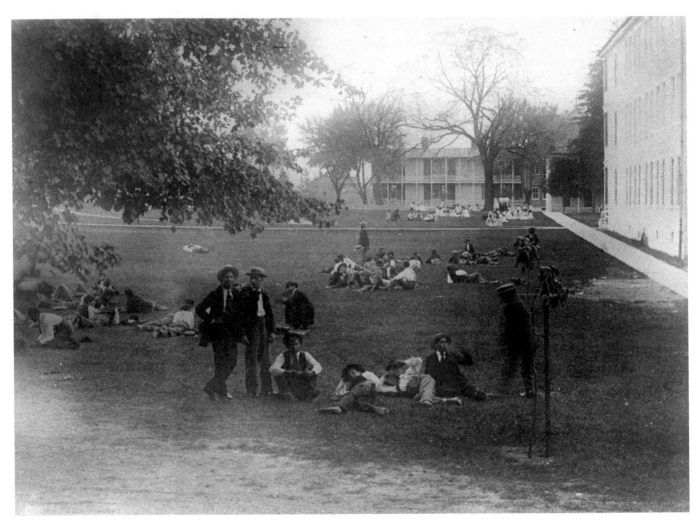

The Carlisle Indian Industrial School, seen here in 1902, was founded in 1879 as a humane alternative to the prevalent harsh treatment of American Indian peoples and culture. By the time the school closed in 1918, more than 10,000 students had passed through its doors, but the school is viewed today as a failure because of its role in the damage inflicted on American Indian culture and identity by programs oriented toward assimilation.

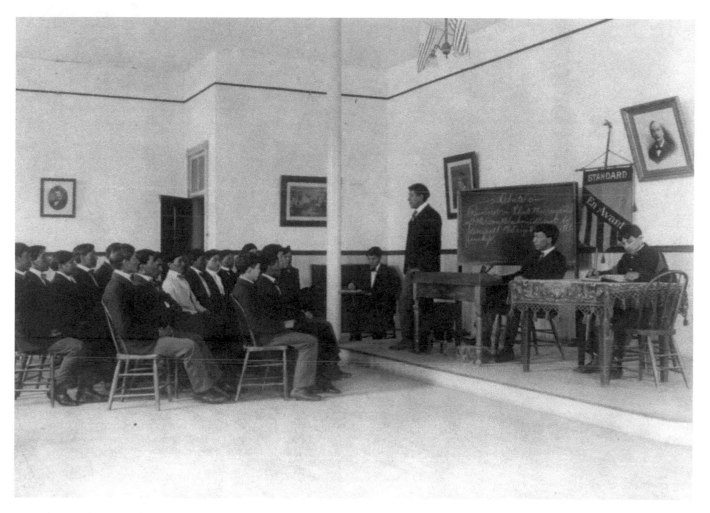

With assimilation as their goal, managers of the Carlisle Indian Industrial School required Native American children to abandon their tribal clothing, cut their hair, and participate in debate classes like this one. In the end, however, the school only achieved an 8 percent graduation rate.

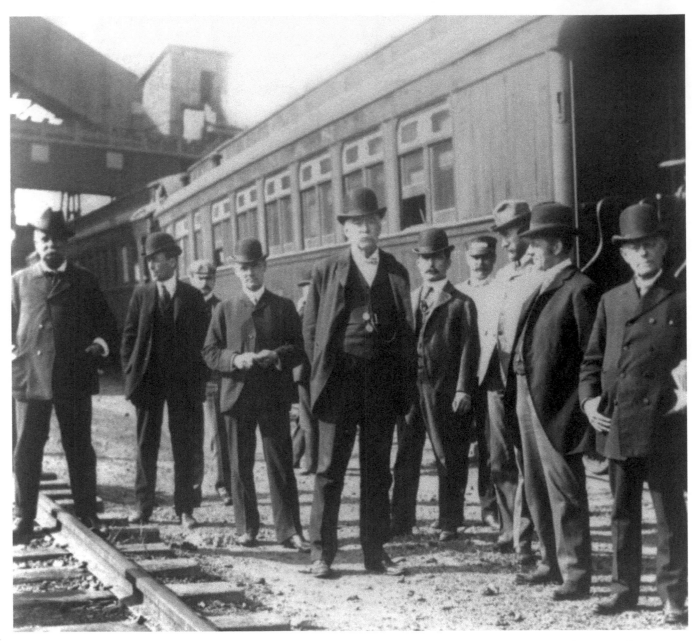

Following an 18-month coal miners' strike that brought violence and tensions throughout the anthracite coal regions of Pennsylvania, President Theodore Roosevelt appointed a Strike Arbitration Commission, seen here in 1902. The strike was quickly resolved, but labor conflicts continued for several decades.

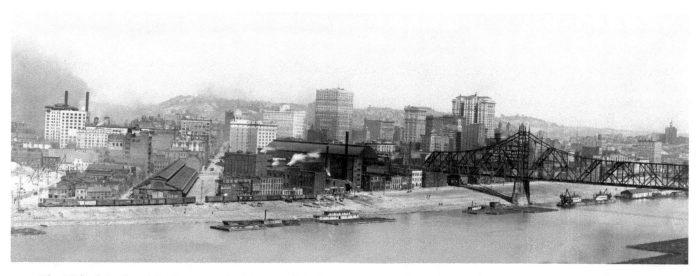

The Wabash Railroad Bridge spans the Monongahela River in Pittsburgh, 1905. The line's large terminal shed is visible at the center of the photo. Built in 1903 after much resistance from the city, the bridge would serve the Wabash Railroad until the company went bankrupt just five years later. Neglected in the years to follow, the bridge was demolished in 1948.

Having founded the Hershey Chocolate Company in Lancaster in 1894, and with Hershey's milk chocolate on the market by 1900, Milton Hershey decided to move his operation to Derry Township, where this Hershey office complex and the chocolate factory behind it opened in 1905.

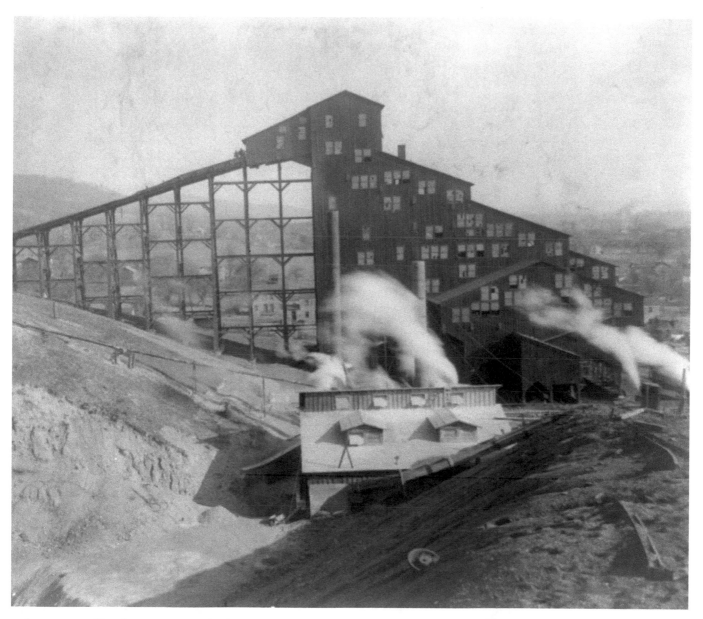

A massive coal breaker in Westmoreland County, 1905. Breakers are used to process raw chunks of mined coal and "break" them down into various sizes suitable for different furnaces. Slag and similar impurities are also removed.

An electric locomotive for use in the mining districts is under construction at Baldwin Locomotive Works, Philadelphia, around 1905. Founded in 1831 as a steam engine manufacturer, the Baldwin firm ultimately produced more than 70,000 locomotives before shutting down in 1956.

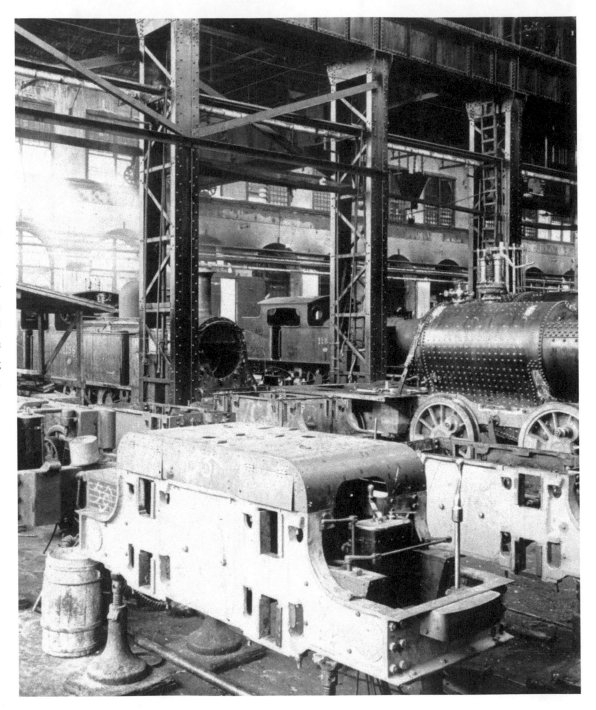

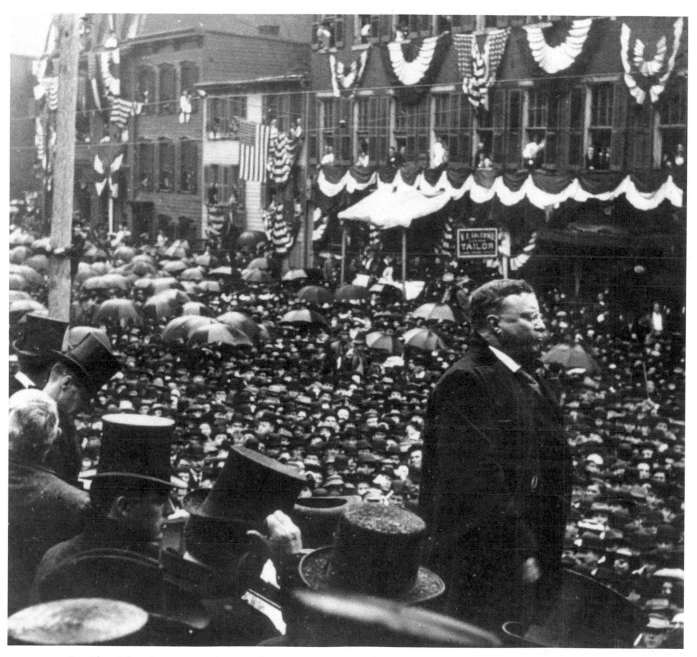

President Theodore Roosevelt, one of many important speakers during the opening ceremonies for the State Capitol in Harrisburg, October 4, 1906.

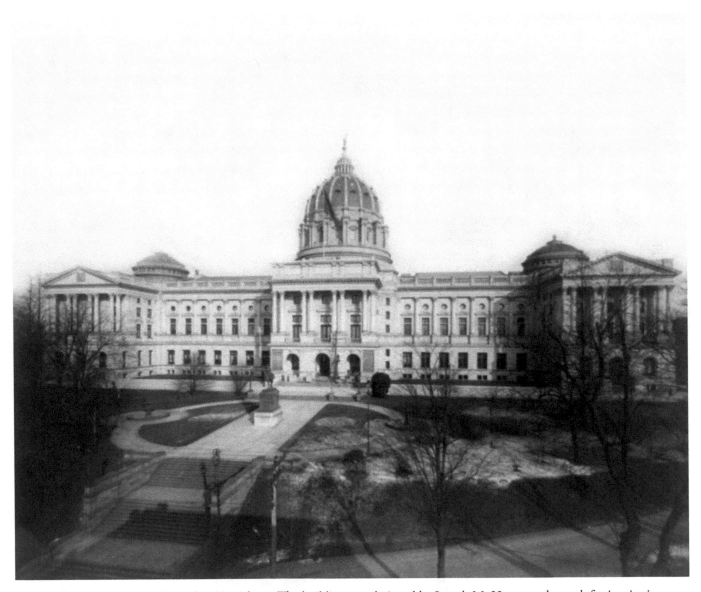

The newly completed State Capitol in Harrisburg. The building was designed by Joseph M. Huston, who took for inspiration such architectural models as St. Peter's Basilica in Rome.

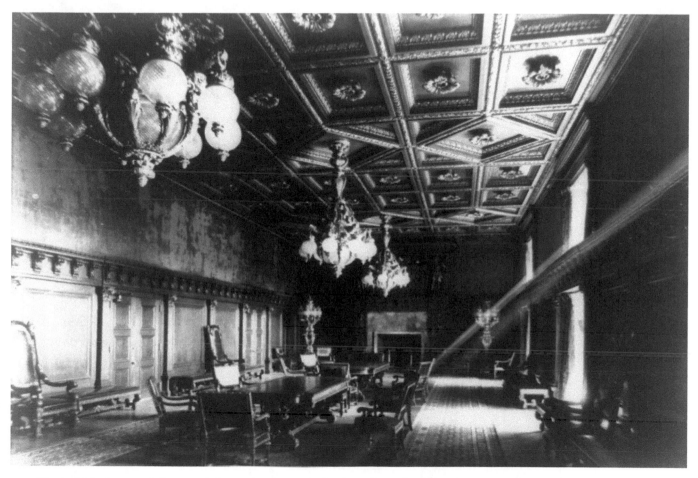

The lavishly decorated Governor's Reception Room in the State Capitol at Harrisburg as it appeared shortly after completion. A remarkable $8.6 million was spent to decorate and furnish the Capitol in time for the official opening in 1906. However, an investigation into the high costs resulted in the indictment for fraud and two-year incarceration of the state's auditor general and treasurer.

A freight
locomotive waits
in the yard of
a steel plant in
Homestead in
1907. Homestead,
in Allegheny
County, was the
site of the violent
and deadly steel
strike of 1892
that was one of
the first organized
labor actions in
the country. In
a single day, 11
men were killed in
conflicts between
workers and
the Pinkerton
Detective Agency,
hired by Carnegie
Steel to end the
strike.

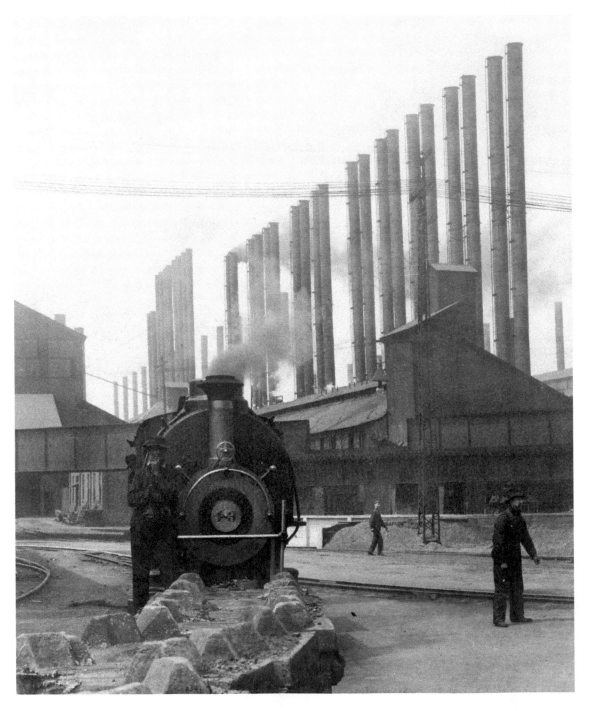

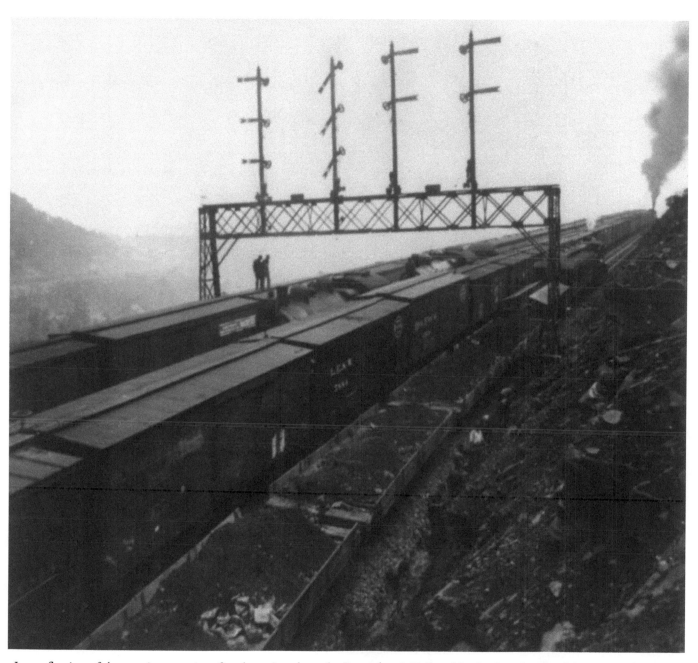

In a reflection of the massive quantity of coal moving along the Pennsylvania Railroad in the first decade of the twentieth century, four full freight trains sit abreast of one another on rails west of Altoona.

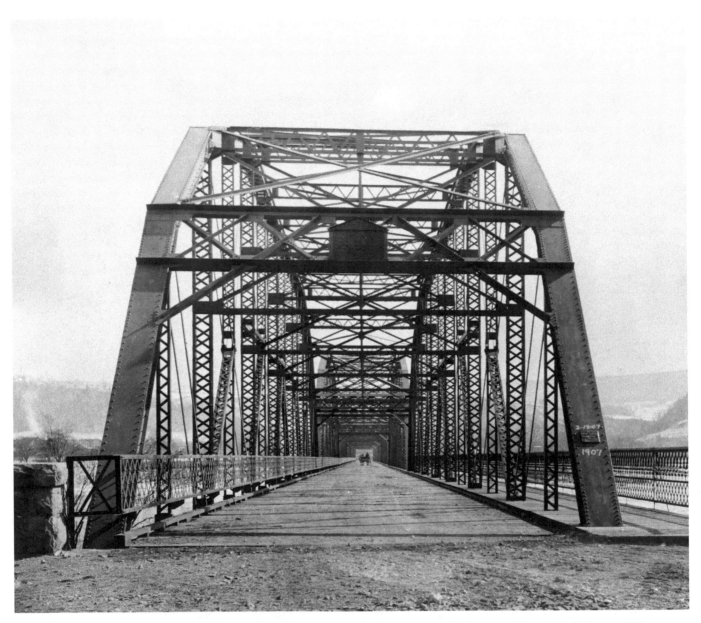

A bridge spans the Susquehanna River in Berwick, Columbia County, 1907. Berwick is home to the regionally known Wise Foods, manufacturers of potato chips.

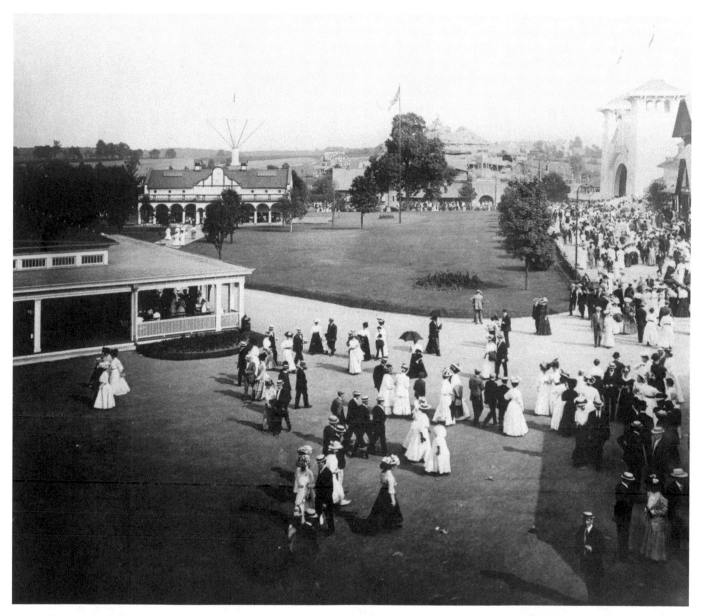

Willow Grove Park, a popular amusement park located north of Philadelphia, opened in 1896 and closed in 1975. Known as a "trolley park" because it was founded by the Philadelphia Rapid Transit Company in an effort to encourage the use of their trolley lines from the city, the park benefited from the growing number of middle-class families seeking varied forms of entertainment and leisure. Seen here in 1907, the site is currently the location of the Willow Grove Park shopping mall.

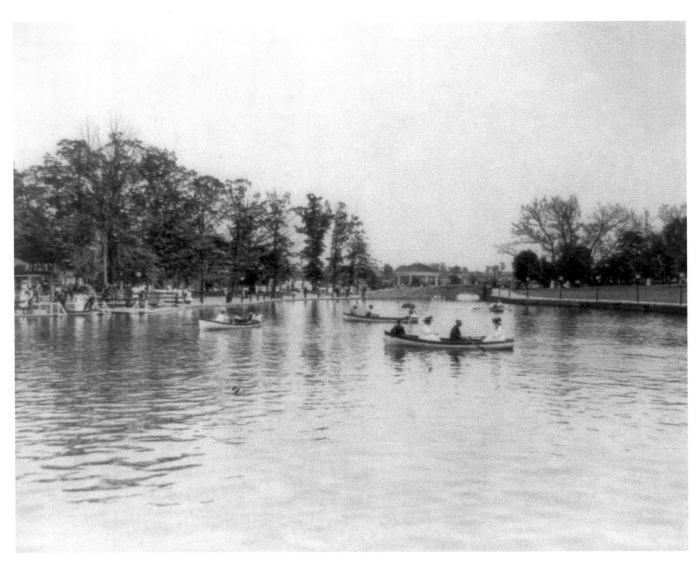

In addition to a world-famous music pavilion that featured performances by John Philip Sousa, Willow Grove Park offered amusement rides, landscaped and manicured walks, and a man-made lake with rowboats for rent.

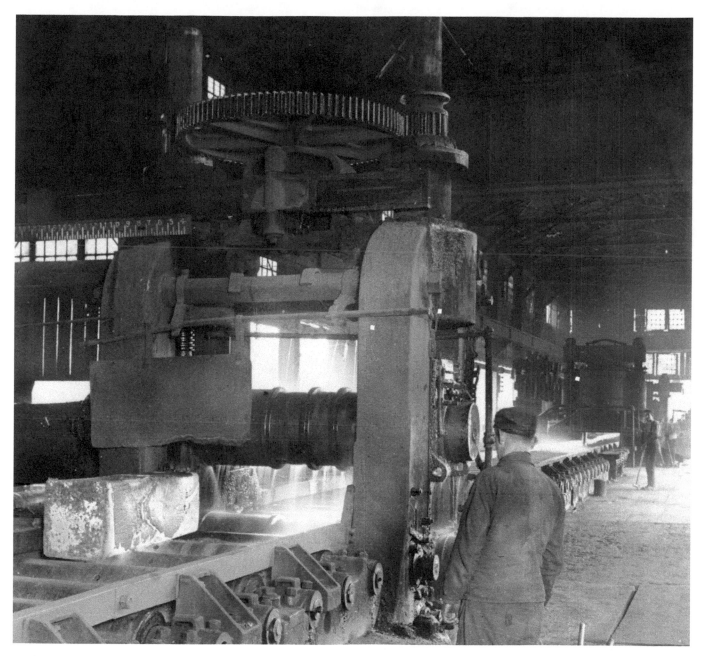

White-hot ingots of steel roll down the line in a Homestead steel mill. In the final steps of the process, each ingot is stretched to a length of 75 feet.

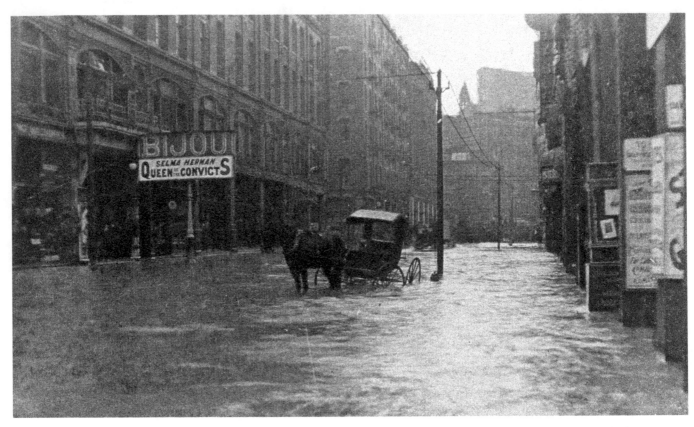

A lone horse and carriage passes the Bijou Theatre on Penn Street in Pittsburgh during a destructive flood that struck the city in March of 1907.

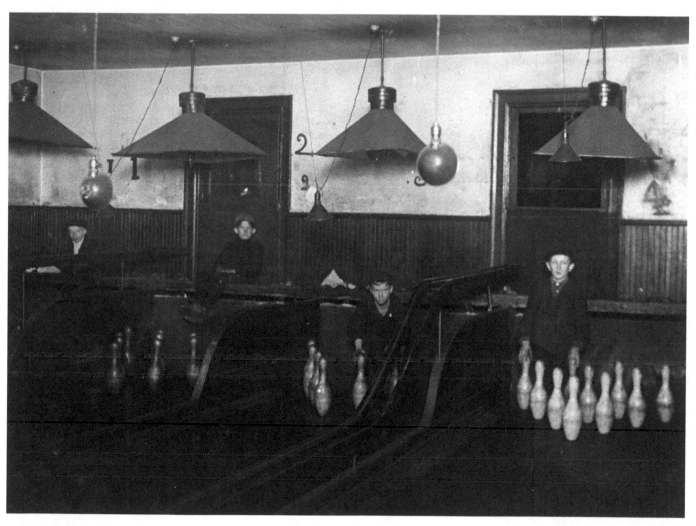

Pin boys work late into the night at a bowling alley in Pittsburgh, 1908. This image is by Lewis W. Hine, who traveled the country as an investigative photographer for the National Child Labor Committee.

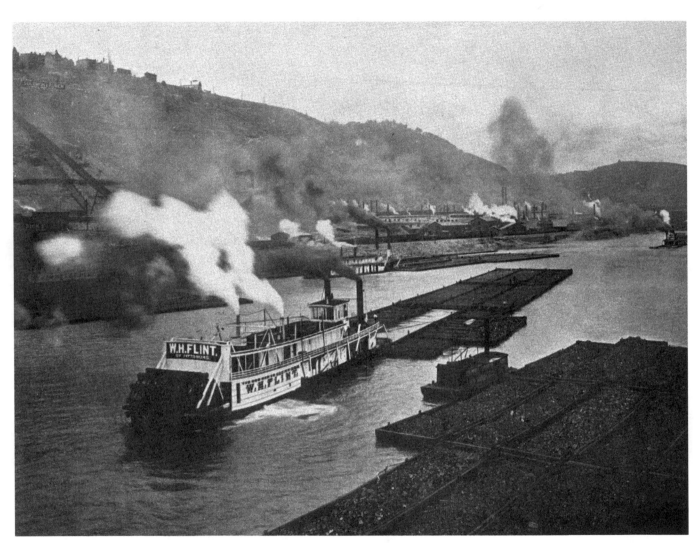

A steam-powered coal barge is maneuvered with a full load along the Ohio River near Pittsburgh in 1908.

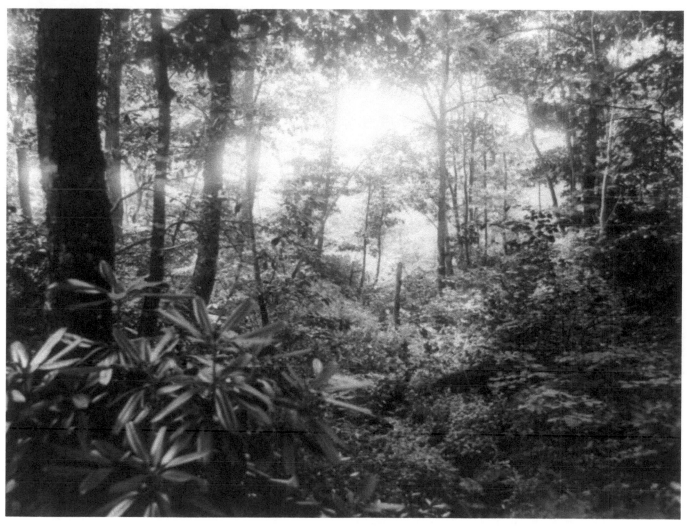

The wooded intersection of Braddock's Road and White Oak Level Road near McKeesport, ca. 1908. Braddock's Road is the route along which British general Edward Braddock led a failed effort to take the French Fort Duquesne and lost his life during the Battle of Monongahela in July 1755.

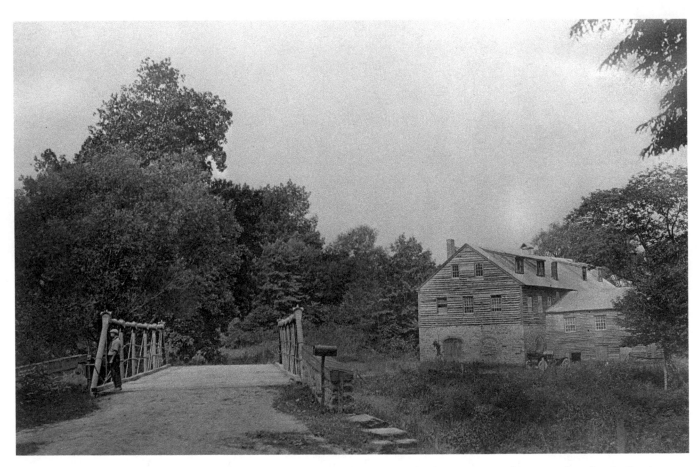

The William Henry family, originally of Lancaster, were among the country's leading gun manufacturers when they built a large new factory near Belfast, Northampton County. The company, which produced weapons for all American conflicts from the American Revolution through the Civil War, went out of business in the late 1800s. The factory and homestead, seen here in 1910, are now part of the Pennsylvania Longrifle Museum in Jacobsburg.

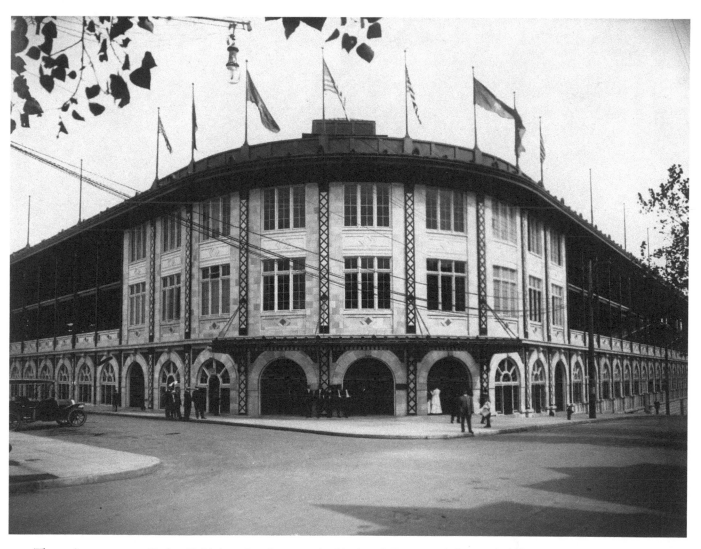

The main entrance to Forbes Field, longtime home to the Pittsburgh Pirates and the Pittsburgh Steelers, ca. 1909. The Pirates lost the first baseball game played at Forbes Field, in 1907, but went on to win three World Series before the last game was played there in 1970.

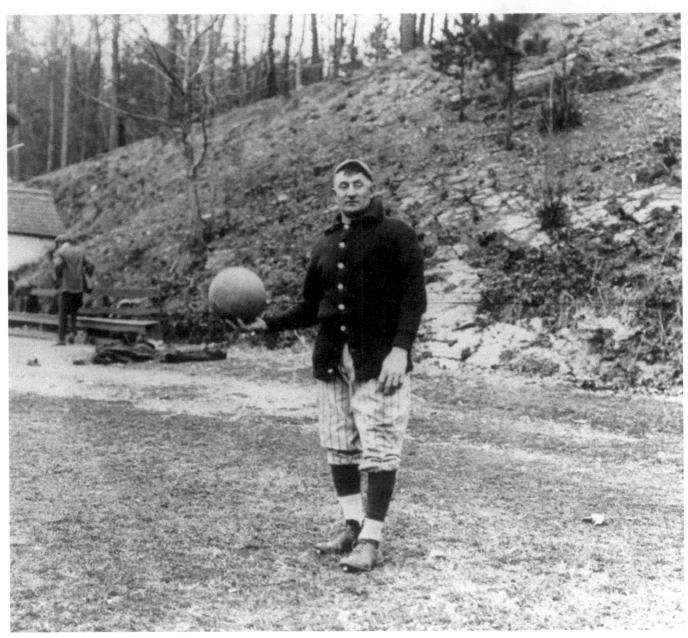

Considered by many to be the greatest shortstop in baseball history, Pittsburgh Pirate John Peter "Honus" Wagner (nicknamed the "Flying Dutchman") poses with a medicine ball around 1910. Wagner was among the first five inductees to the Baseball Hall of Fame in 1936.

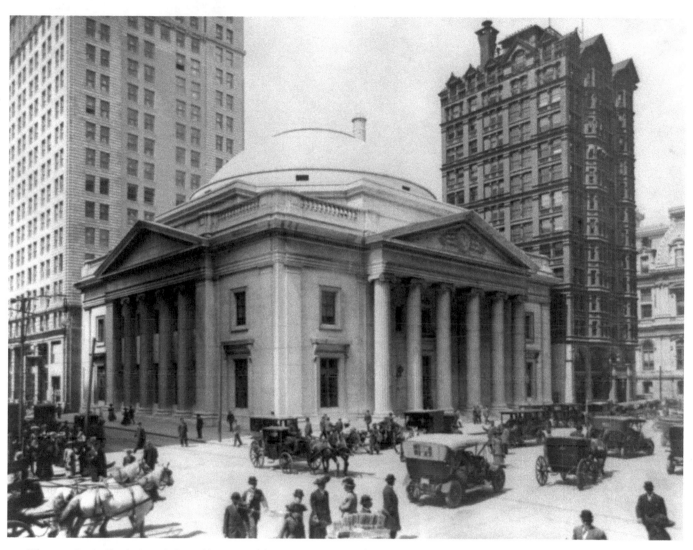

The neoclassically designed Girard Trust Building on South Broad Street in Philadelphia, ca. 1910. Following the addition of a 300-room tower next to the original domed building, the former bank building is now home to the Ritz Carlton Hotel.

Two newsboys wait in front of a corner cigar store in Philadelphia, hoping to get tobacco coupons from sympathetic customers.

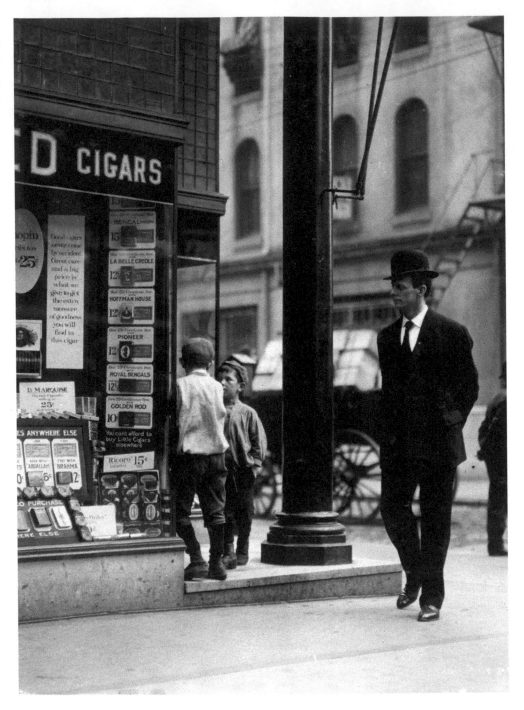

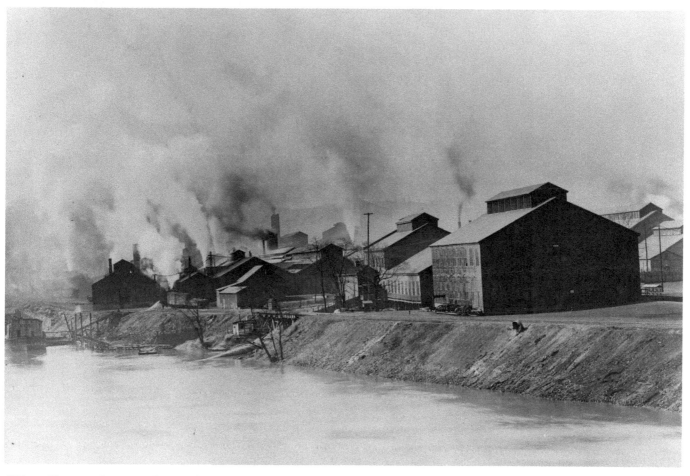

Wire mills, manufacturers of wire cable, in Donora, Washington County, ca. 1910. The smoke seen here foretells of a fatal level of pollution reached in the town October 30-31, 1948, when 19 people died within a period of 24 hours.

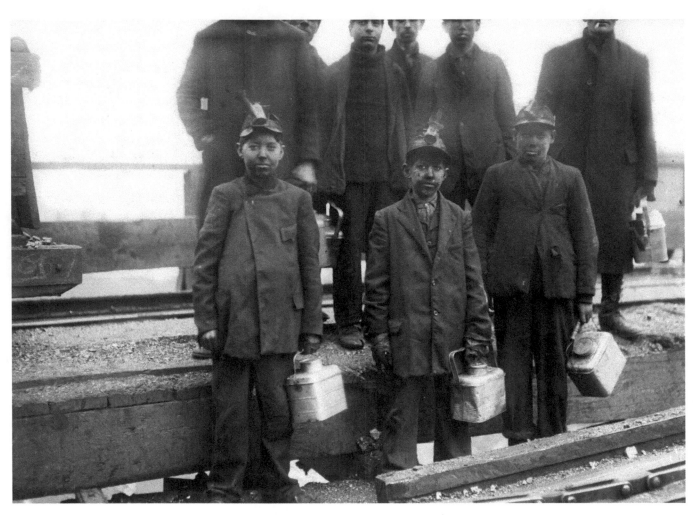

Young boys outside Shaft No. 6 of the Pennsylvania Coal Company mine in South Pittston, Luzerne County, December 1910. Through photographs like this one, investigative photographer and social documentarian Lewis W. Hine hoped to expose the use of young children in dangerous industries such as coal mining.

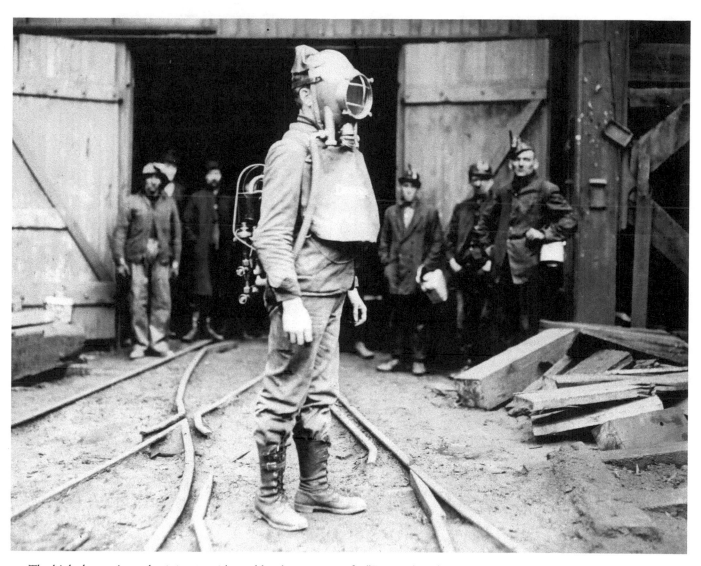

The high danger in coal mining is evidenced by the presence of a "First Aid to the Injured" worker, fully outfitted in a Draeger Oxygen Helmet designed to aid breathing in toxic environments. This photo was taken at the Avondale Shaft, D. L. W. Colliery in Luzerne County, the site of a particularly deadly mine fire in 1869.

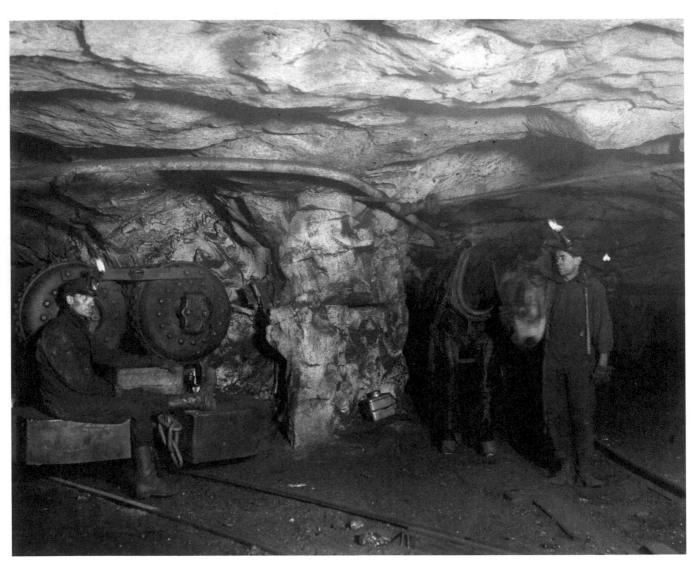

Mules and children worked side by side with motorized trucks and men in many coal mines, including Shaft No. 6 in South Pittston on this day in January 1911.

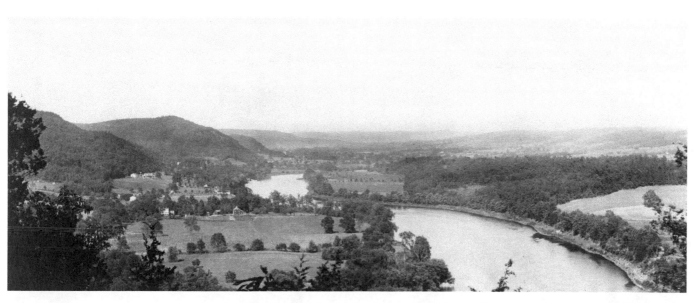

A view north over the Delaware River at Dingmans Ferry, Pike County.

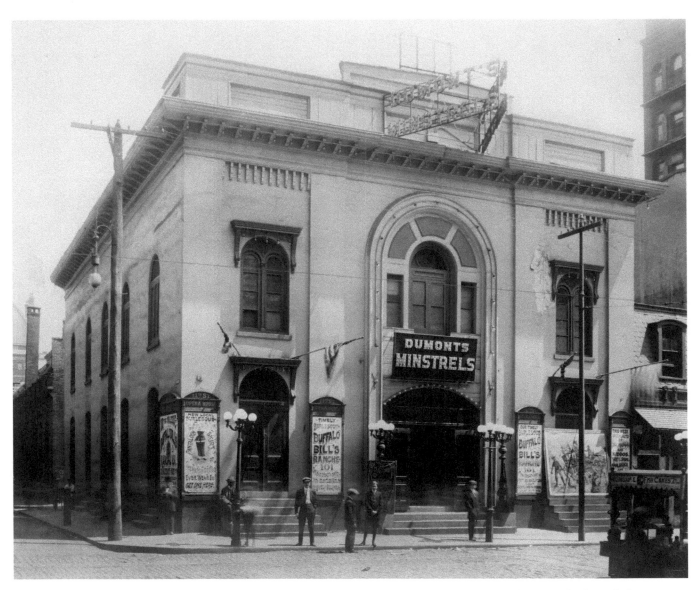

One of several minstrel and burlesque houses in Philadelphia, Dumont's Opera House was located on North Eleventh Street near Ranstead Street.

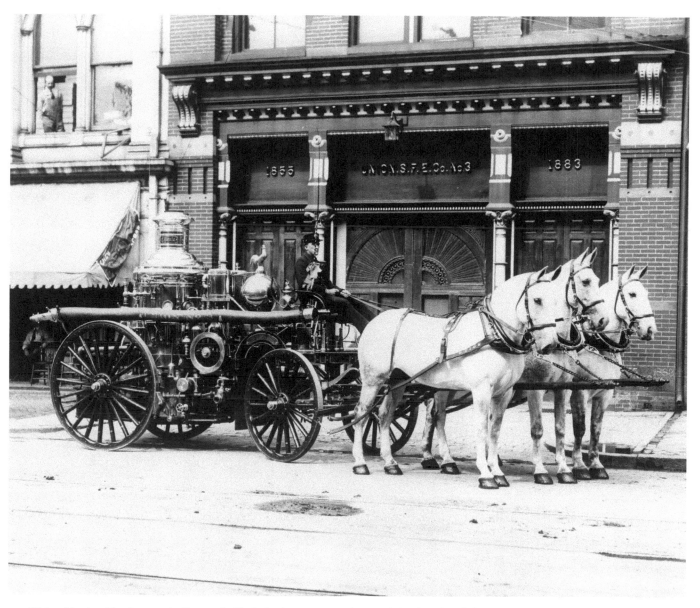

Union Engine No. 3 poses in front of a York fire house, around 1911. The first fire-fighting unit in York was the volunteer Sun Fire Brigade, organized in 1771.

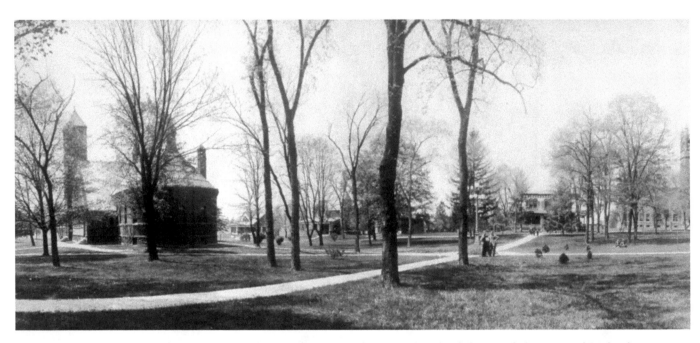

The campus of Pennsylvania College in Gettysburg in 1913, with the Brua Chapel at left. Founded in 1832, the school was renamed Gettysburg College in 1921.

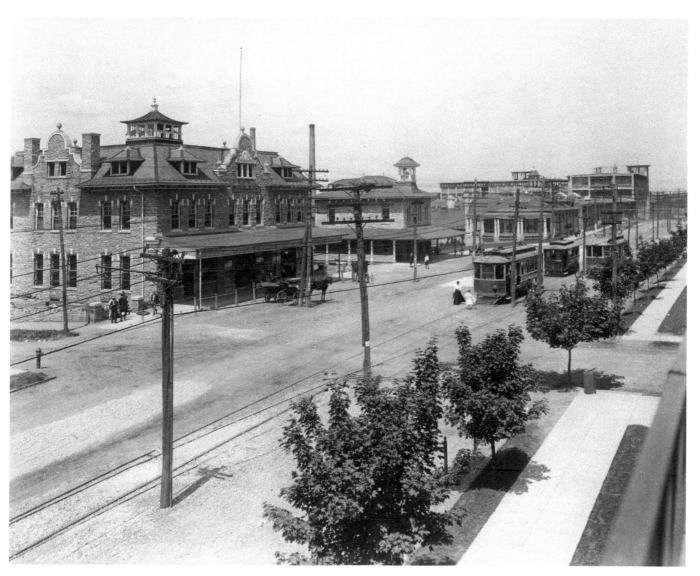

With the Hershey chocolate factory opening in Derry Township in 1905, a company town developed by Milton Hershey grew up around it. Viewed in 1913, trolley-lined Chocolate Avenue features Cocoa House—home to the local YMCA and other organizations—at far left, along with the Volunteer Fire House, the Hershey Cafe, and the chocolate factory at the far end of the street.

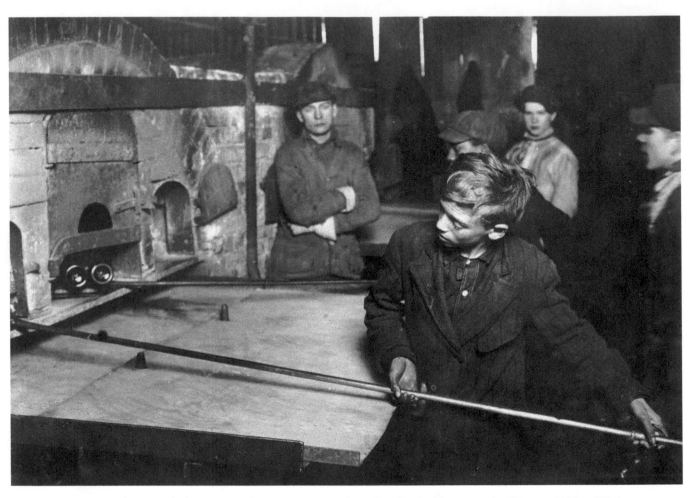

This Lewis W. Hine photograph shows young boys preparing molten glass for the blowers at the Wormser's Glass Works in Pittsburgh.

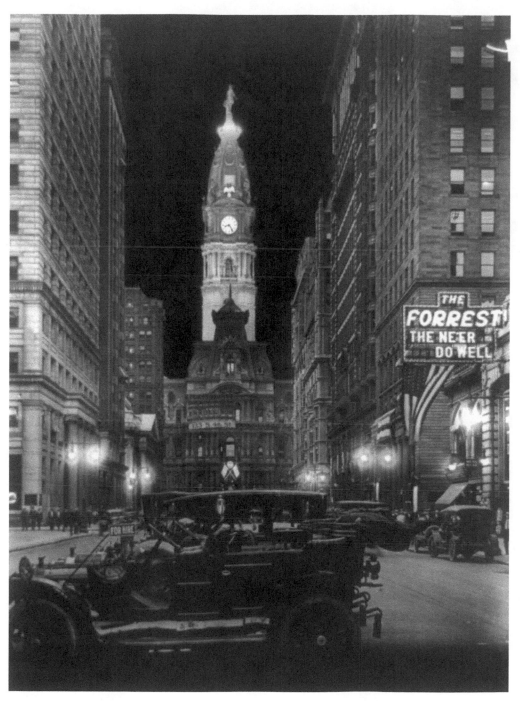

The scene at night, viewed north on Broad Street toward Philadelphia's City Hall, 1916. The City Hall tower, built in the 1890s, remains the world's tallest masonry structure bearing a statue (of city founder William Penn).

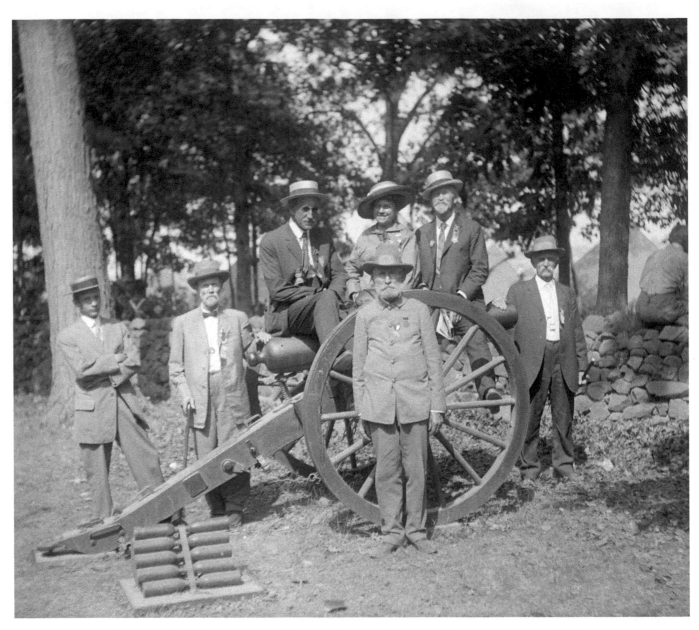

During the time of the First World War, members of the Grand Army of the Republic, an organization of Union veterans of the Civil War, gathered for a reunion in Gettysburg. The woman at center is perhaps a member of the auxiliary Woman's Relief Corps.

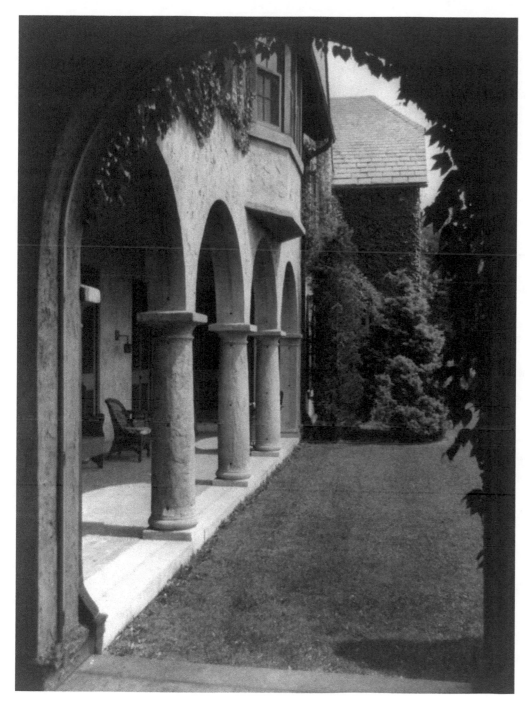

The grand side entrance to Allgates, the home of Horatio Gates Lloyd in Haverford, Delaware County. Built by Wilson Eyre in 1910, the 75-acre estate was known for its remarkable gardens.

Sightseers cross a wooden bridge at one of eight dramatic falls in Bushkill Falls in 1919. The combined "Niagara of Pennsylvania" along Bushkill Falls Creek remains a major tourist attraction.

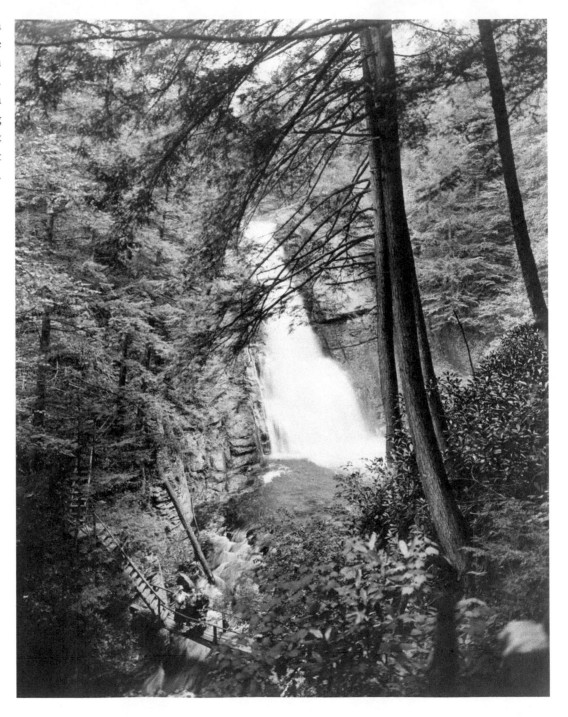

# Peaks and Valleys

## (1920–1949)

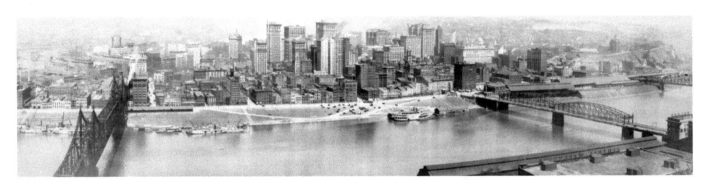

A view north across the Monongahela River shows the downtown Pittsburgh skyline around 1920.

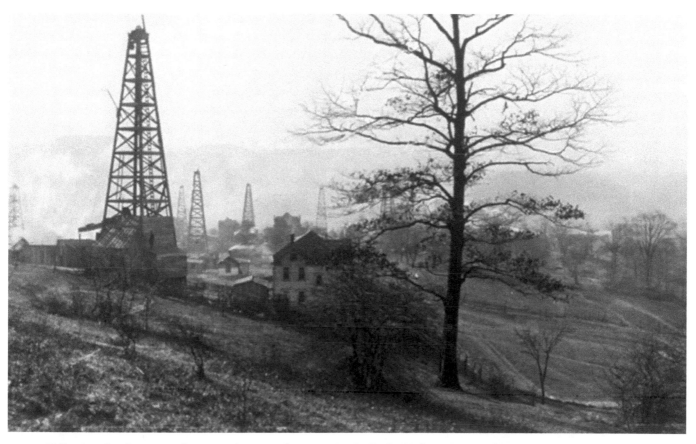

Following the discovery of an extensive natural gas vein in the Snake Hollow section of McKeesport in 1918, more than $1 million in gas was extracted within the first few years, and the northwestern region of the state experienced a tremendous economic boom.

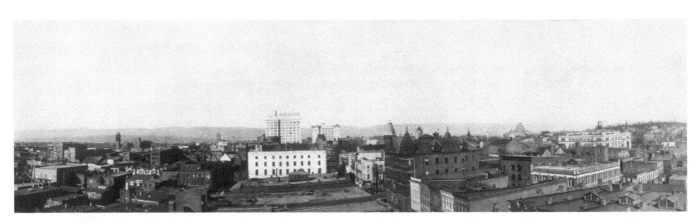

The city of Wilkes-Barre, county seat of Luzerne County, as seen from the Redington Hotel in 1921.

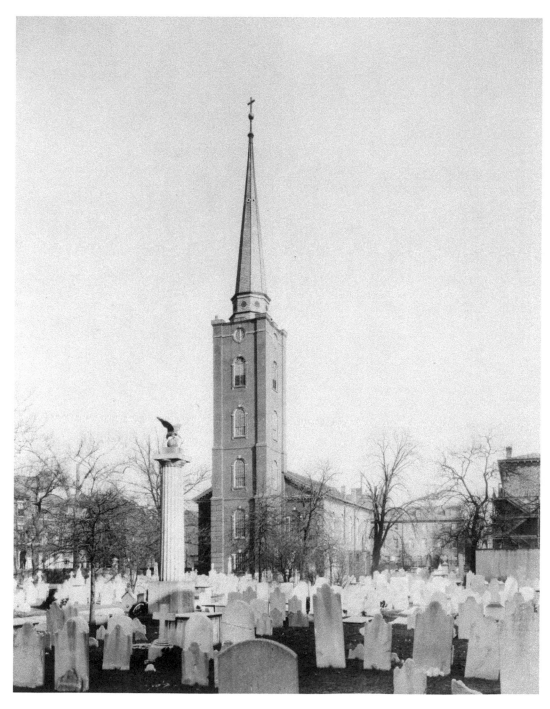

Philadelphia's second Episcopal church, St. Peter's, was established in 1761 to serve the growing numbers of residents living along what was then the southern boundary of the city near South Street. Notable burials in the churchyard include artist Charles Willson Peale and naval hero Stephen Decatur, whose monument rises above all others in this view from 1920.

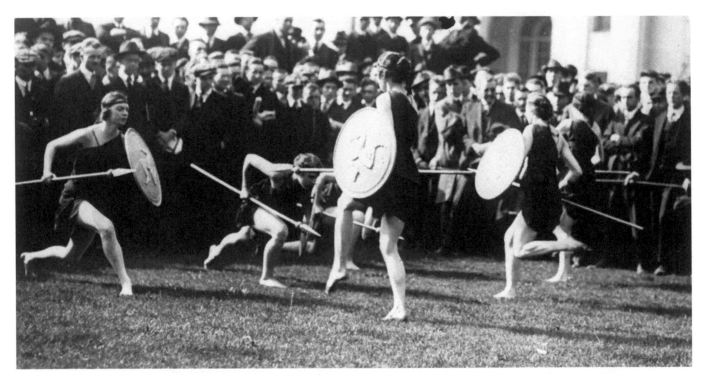

In a performance for the Carnegie Institute of Technology in Pittsburgh (ca. 1920), the Marion Morgan Dancers exhibit Morgan's trademark use of free-flowing togas and bare feet in unique modern dance interpretations of classic works of ballet. Morgan went on to choreograph dance sequences for Hollywood.

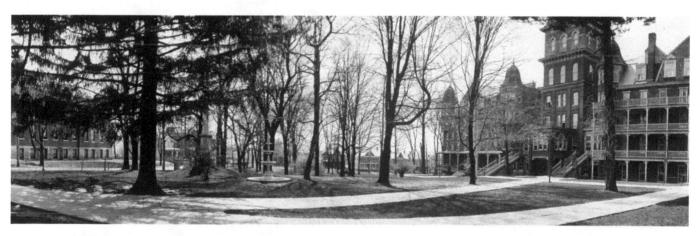

Established in 1855, the Lancaster County Normal School, the first "normal school" in Pennsylvania, prepared high school graduates to be teachers. The school was called the Millersville State Normal School when this photograph was taken in 1921, and now serves a broader educational purpose as Millersville University.

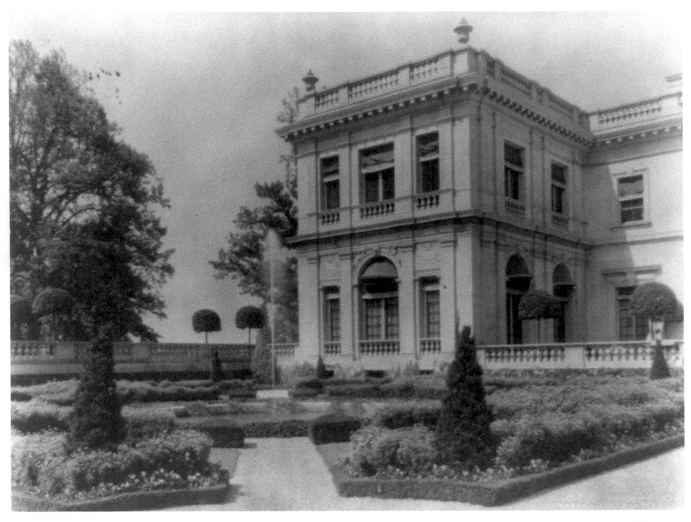

Featuring a remarkable 150 rooms, 28 bathrooms, and 3 elevators, Whitemarsh Hall in Montgomery County was one of the country's most extravagant private homes. Designed by classical architect Horace Trumbauer for banker Edward Stotesbury, the estate was completed in 1920 at a cost of over $3 million. It was demolished in April of 1980.

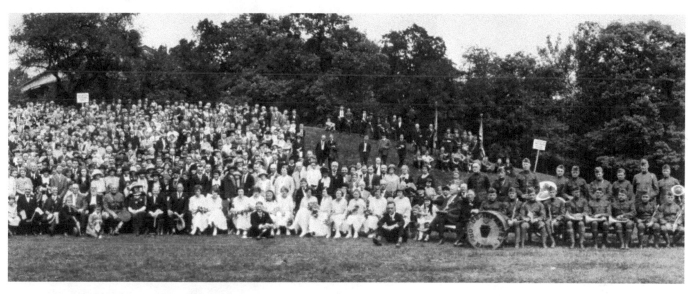

Attended by the 110th United States Infantry Band, a Pershing family reunion is captured in Idlewild Park, Westmoreland County, on September 8, 1923. The family's most famous member, General John J. Pershing, appears to be the man in uniform at left in the front row.

Stanley Harris, manager of the Washington Senators, shakes hands with opposing manager and baseball icon Connie Mack of the Philadelphia Athletics in 1924, the year the Senators went on to win the World Series. Mack served a remarkable 49 years as the A's manager, 1901–1950.

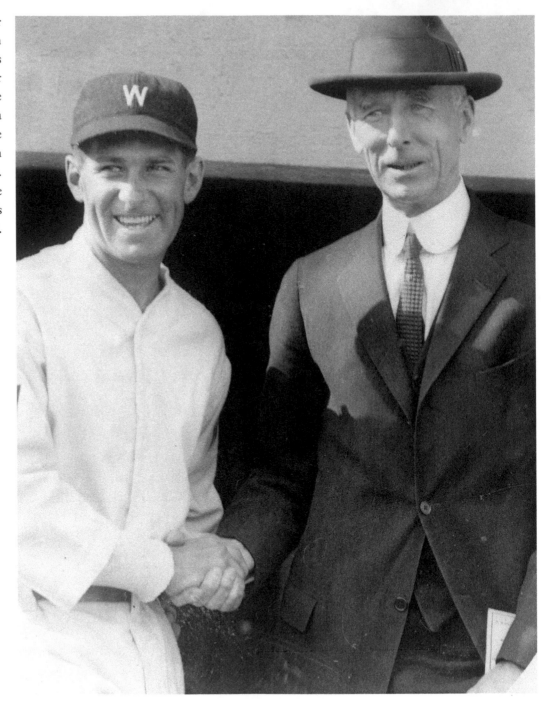

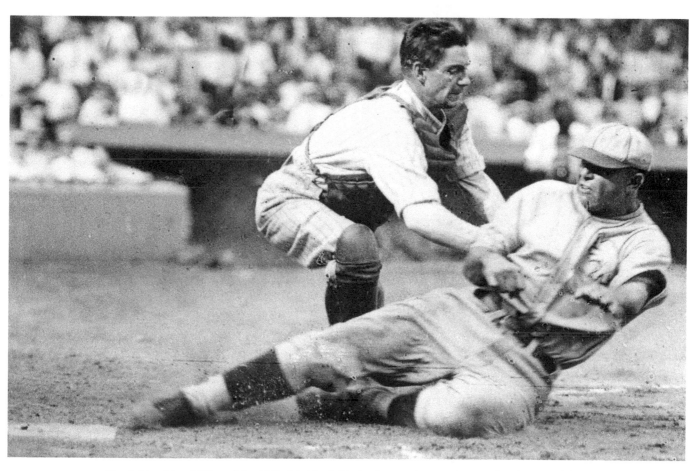

Outfielder Bing Miller of the Philadelphia Athletics is tagged out at home plate by Herold "Muddy" Ruel of the Washington Senators.

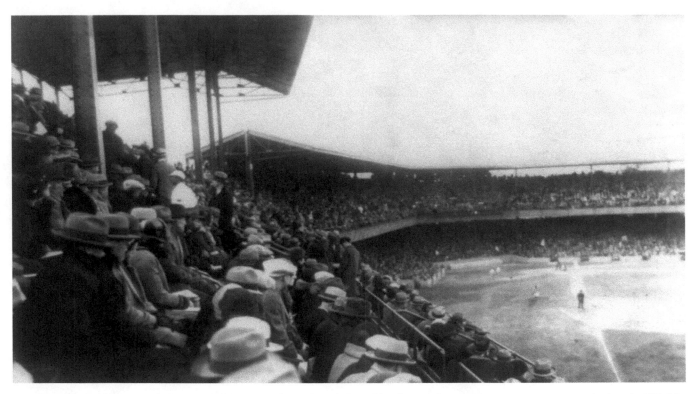

In 1925, the champion Washington Senators were themselves defeated by the Pittsburgh Pirates in seven games during the World Series. Here, spectators watch the two pennant winners at play at Forbes Field in Pittsburgh.

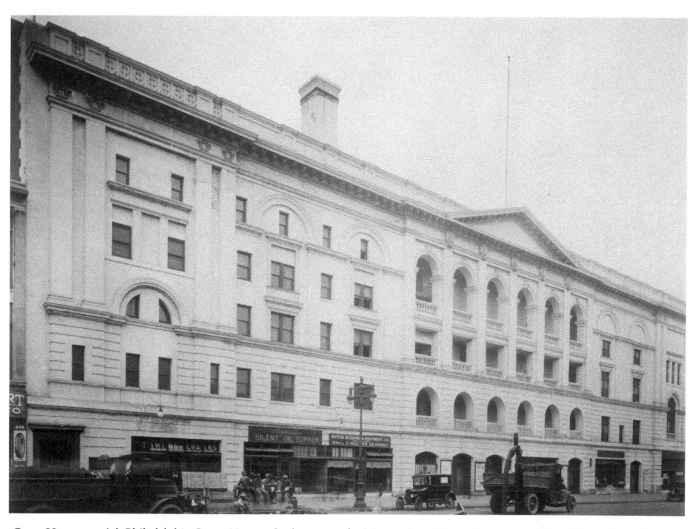

Oscar Hammerstein's Philadelphia Opera House, also known as the Metropolitan Opera House, opened on North Broad Street in 1908 to great acclaim. Within four years, Hammerstein sold his interest in the opera house to millionaire Edward T. Stotesbury. Seen here around 1925, the building has been used as a church since 1948.

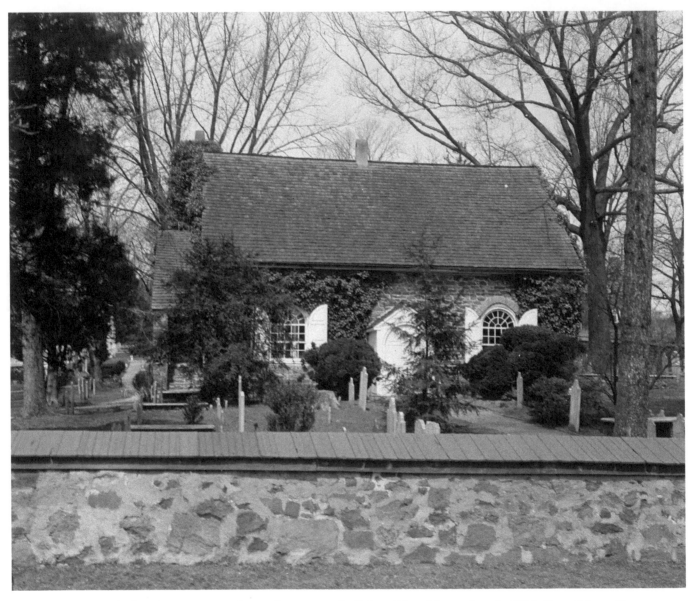

St. David's Episcopal Church in Wayne, Delaware County, was built in 1715 and is seen here in 1925. One of the earliest non-Quaker churches in the state, St. David's would bear witness to the rapid development of the town of Wayne in the 1890s into one of the string of bedroom communities along the Main Line.

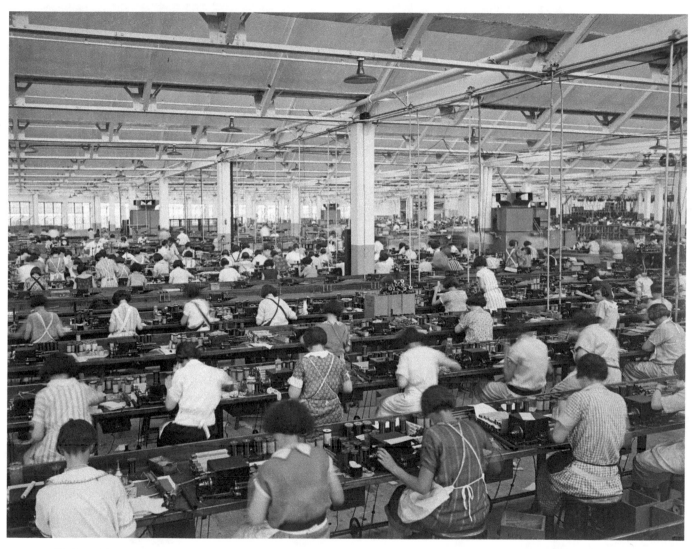

Workers labor at the Atwater Kent Manufacturing Company factory on Wissahickon Avenue in Philadelphia. Originally a manufacturer of small electronic parts, the company was the single largest producer of radios in the country by 1925 and within five years employed more than 12,000 people.

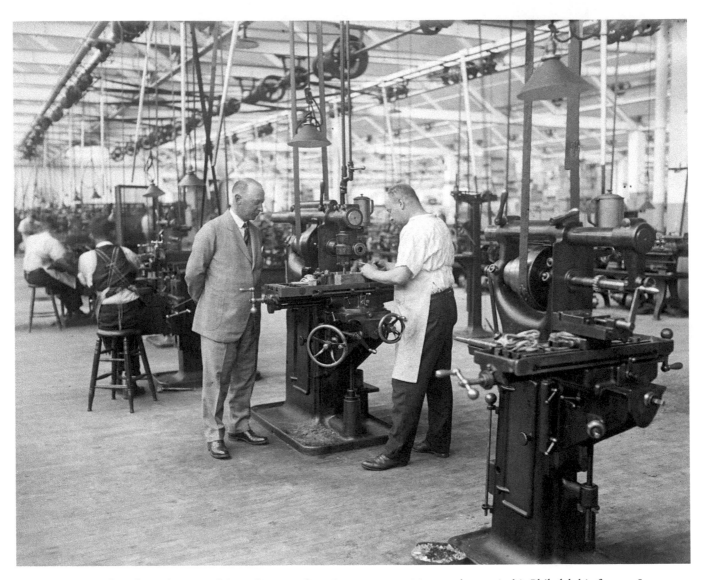

A. Atwater Kent, founder and owner of the radio manufacturing company, visits a tool room in his Philadelphia factory. In 1929, Kent shifted the company's production from small tabletop radios to large floor models. However, the advent of the Great Depression resulted in the failure of the company, which closed in 1936.

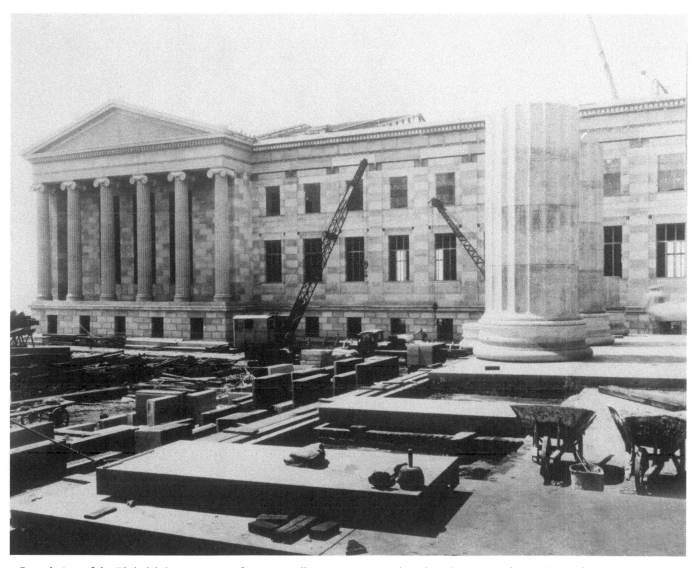

Completion of the Philadelphia Museum of Art was still two years away when this photo was taken in June of 1926. Designed by Horace Trumbauer and the architectural firm of Zantzinger, Borie and Medary, the Greek-revival building stood on ten acres of reclaimed land that was once the site of the Fairmount Reservoir.

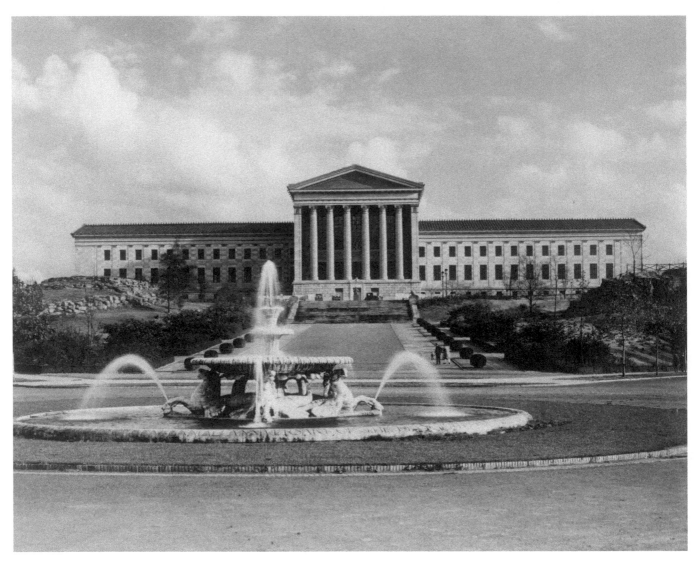

The newly completed Philadelphia Museum of Art on Benjamin Franklin Parkway in Fairmount Park in 1928. The "Fountain of the Sea Horses," a replica of Bernini's original in the Borghese Gardens in Rome, is seen in the foreground.

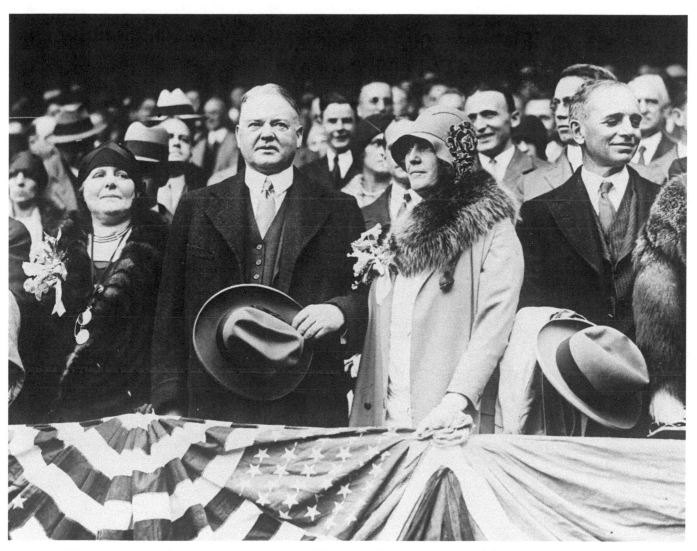

President and Mrs. Herbert Hoover attend the World Series at Shibe Park in Philadelphia, October 1929. The Philadelphia Athletics defeated the Chicago Cubs in five games to win the Series for the fourth time.

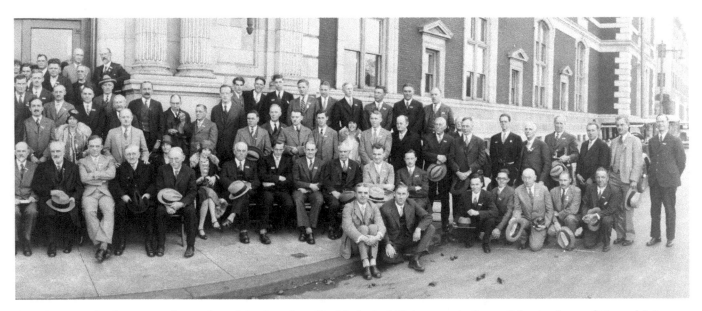

Participants at the forty-seventh meeting of the American Ornithologists' Union pose in front of the Academy of Natural Sciences in Philadelphia, October 1929. Founded in 1812 and home to the world's first assembled dinosaur fossil skeleton, the academy remains one of the finest natural history museums in the country.

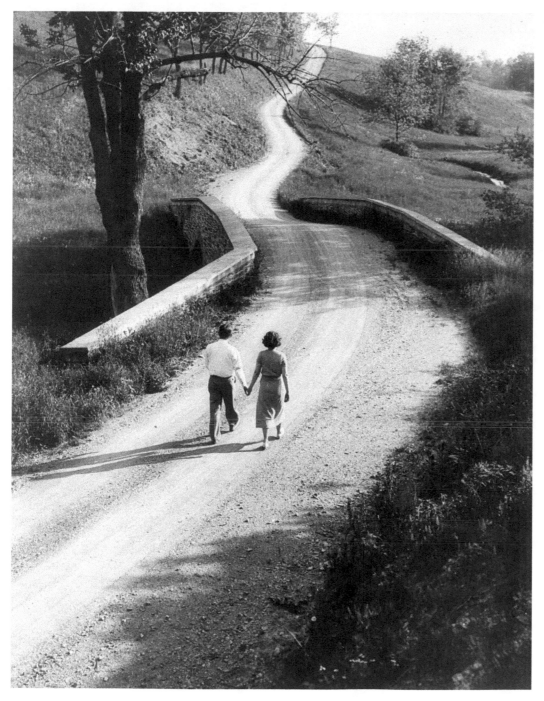

A couple enjoys a lovely stroll along a country road somewhere in Pennsylvania in the early 1930s.

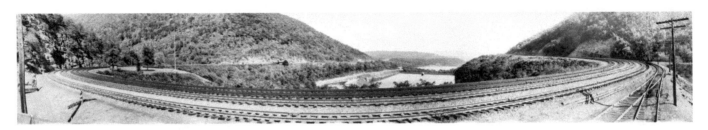

The Horseshoe Curve at Altoona, October 12, 1934. This remarkable feat of engineering has been in continuous use since it opened on February 15, 1854. Designed to ensure safe and efficient passage of trains through the Allegheny Mountains, the Horseshoe Curve was made a National Historic Landmark in 1992.

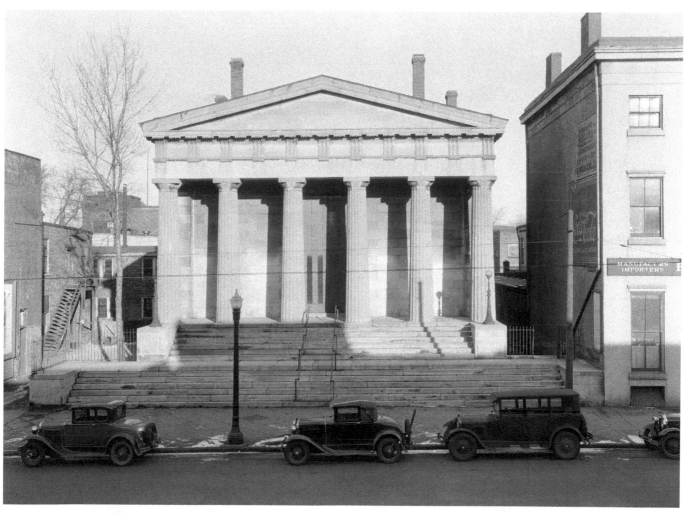

Currently home to the Erie Art Museum, the Old United States Customs House is seen here on January 21, 1935.

St. Peter's United Lutheran Church on North
Union Street in Middletown, Dauphin County.
Seen here in March 1935, the structure was
built in 1767 and is still home to an active
congregation today.

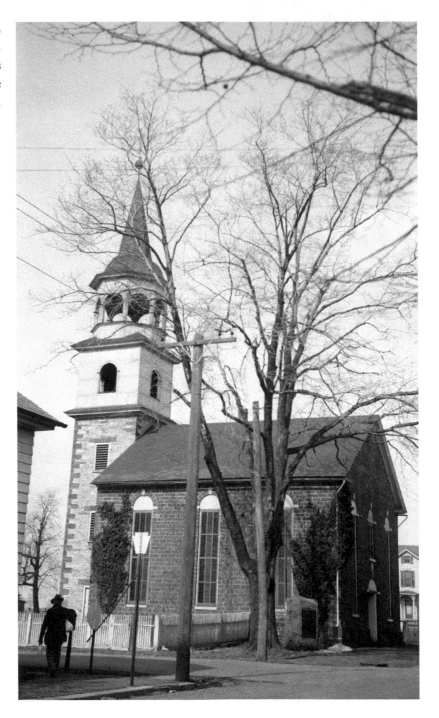

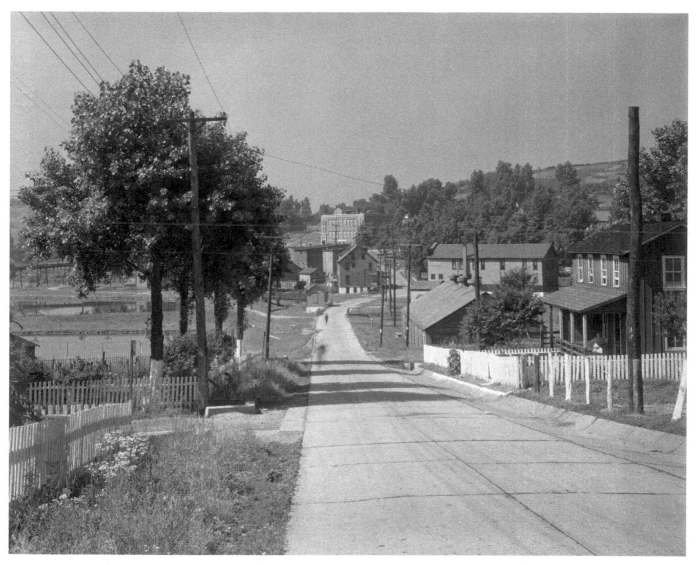

This unidentified mining town in Westmoreland County grew up around one of the several coal mines owned by the H. C. Frick Coke Company. Coke, a product of coal, is essential in the production of steel. In the 1880s, Henry Clay Frick formed an exclusive partnership with Andrew Carnegie in a company which would later become United States Steel. This photograph was taken by Walker Evans, one of several noted photographers employed on federal documentary projects during the New Deal and World War II years.

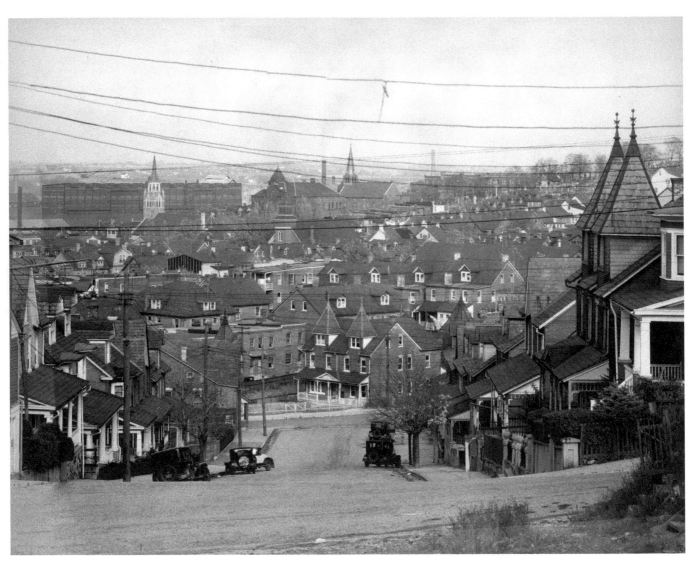

Bethlehem, Pennsylvania, as photographed by Walker Evans in November 1935. The town was founded along the Lehigh River on Christmas Eve 1741 and straddles the boundary between Lehigh and Northampton counties. Created as a Moravian community with all land owned by the church, the town was first opened to non-Moravians in the 1850s.

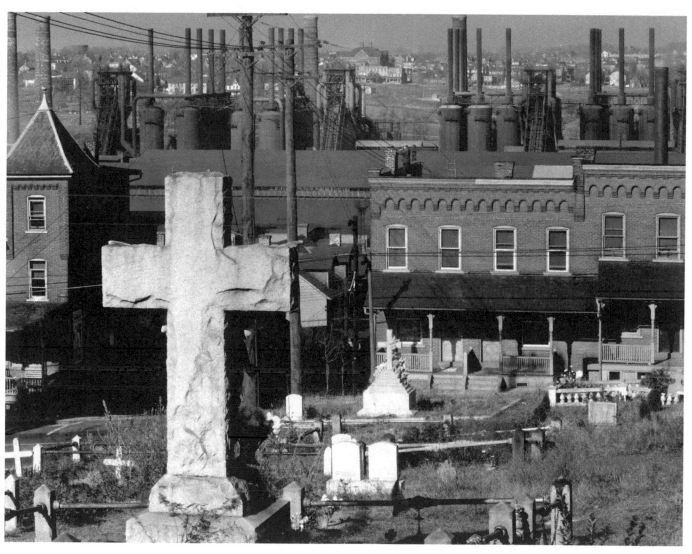

Seen from a neighborhood graveyard in Bethlehem, the stacks of Bethlehem Steel are visible in the distance. The Bethlehem Steel plant, founded in the 1850s and once the second-largest steel manufacturer in the country, closed in 1995.

A mysterious double-deck privy looms on a farm in Pennsylvania in the late 1930s.

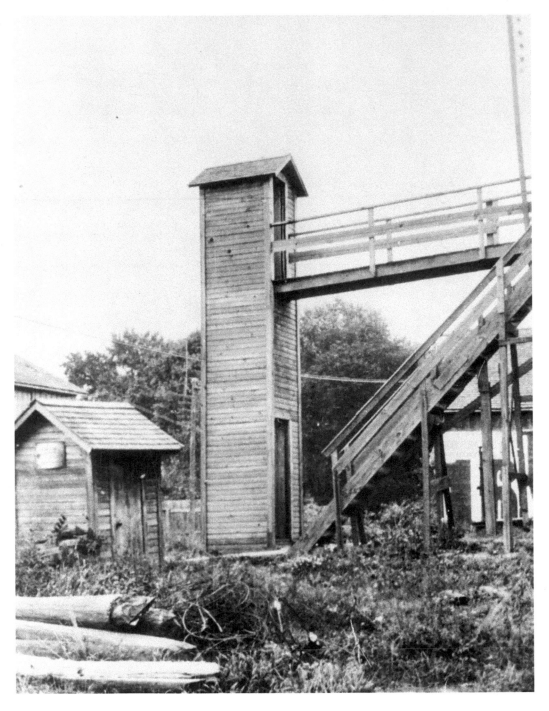

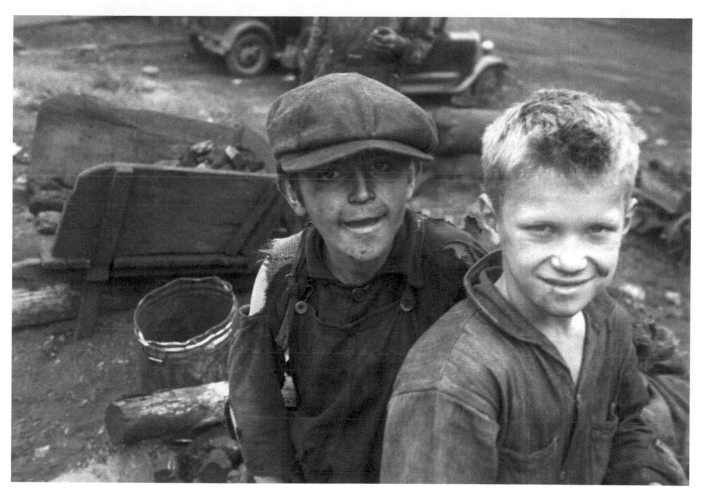

Typical of many coal towns, Nanty Glo, along the Blacklick Creek in Cambria County, grew up around a number of mines at the end of the nineteenth century. These boys, photographed in 1937, worked to retrieve coal scraps from slag piles that resulted from the mining process.

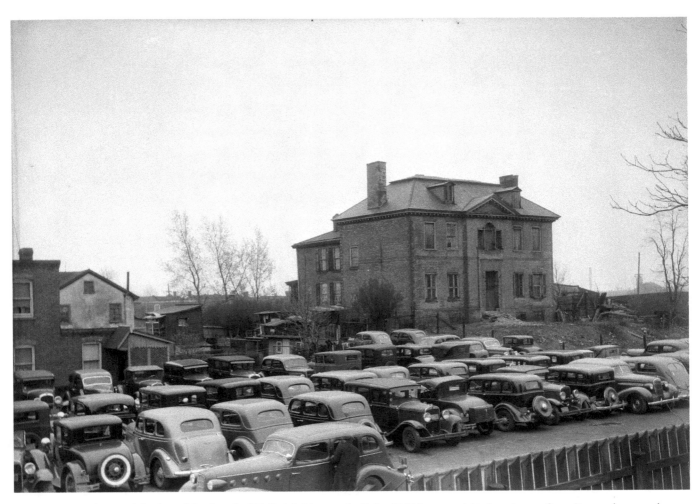

Port Royal, in the Frankford neighborhood of Philadelphia, was built in 1761 by a wealthy immigrant from Bermuda named Edward Stiles. With the grand Georgian home nearing demolition at the time of this photograph in 1937, architectural elements were removed and reconstructed as part of Henry Francis du Pont's home, now the Winterthur Museum and Estate in Delaware.

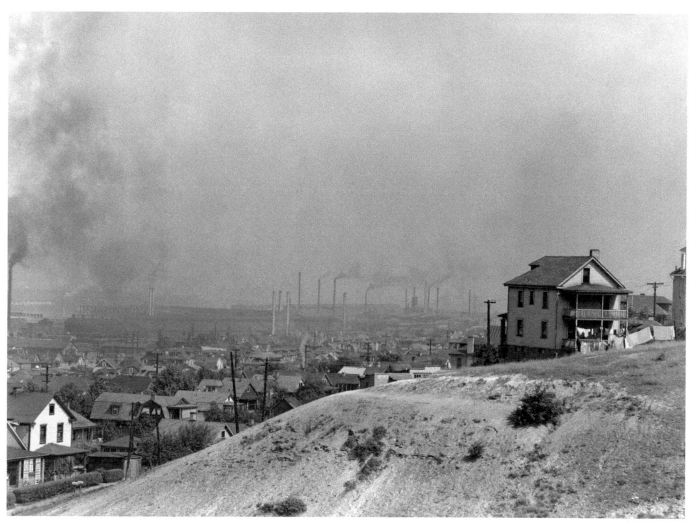

Incorporated in 1905 after the American Bridge Company purchased land from a religious sect, the town of Ambridge is seen here in July 1938. The large smokestacks featured in the photo are representative of the historical importance of steel manufacture to the town.

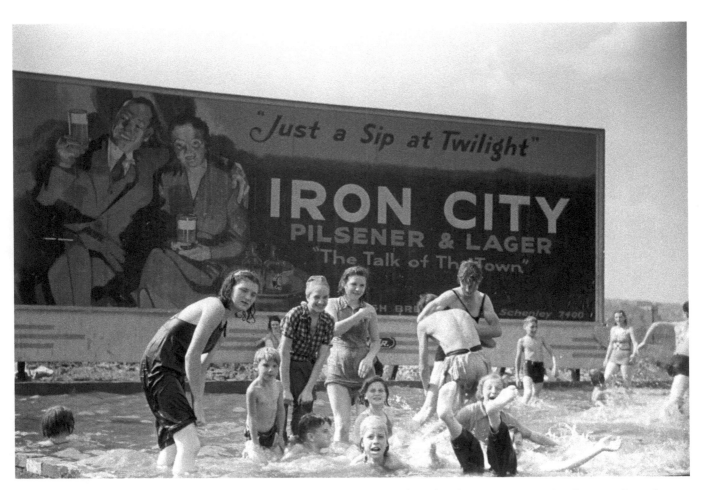

Under the watchful eye of a billboard advertising beer, children of Pittsburgh steelworkers enjoy a swim in a homemade pool, July 1938.

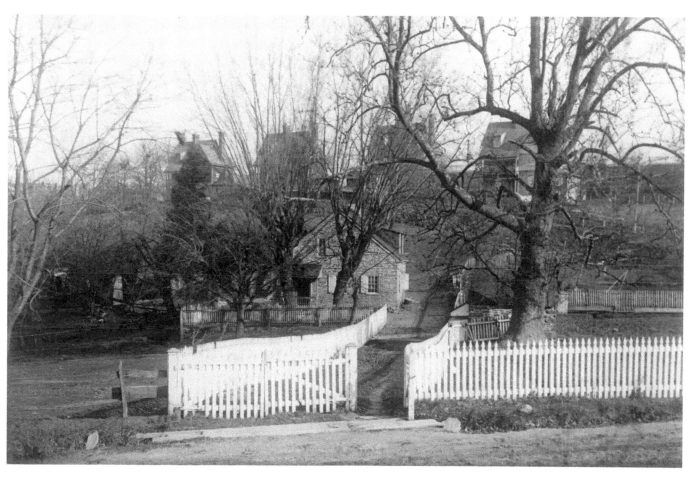

Buttercup Cottage, an old farmhouse along Cresheim Valley Drive in the Chestnut Hill neighborhood of Philadelphia, was used for a time as a retreat for young working women in the 1880s.

The Liberty Bell is shown on display in the south entrance hall of Independence Hall in the late 1930s. The bell was moved to a new permanent home across the street at midnight on January 1, 1976, in preparation for the celebration of the nation's Bicentennial.

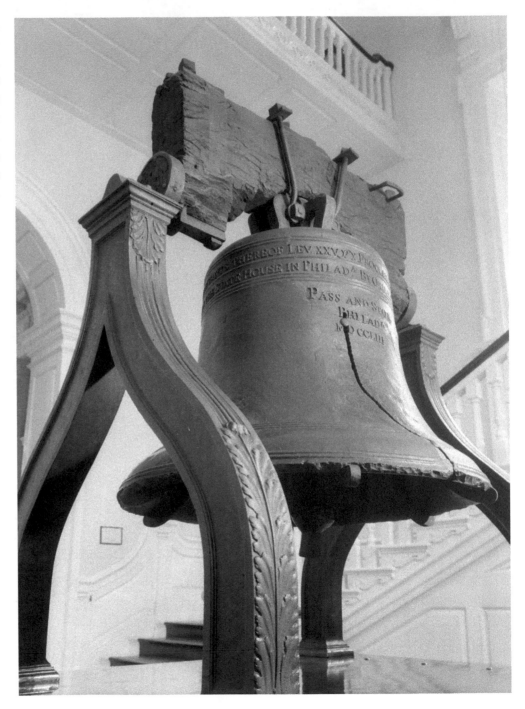

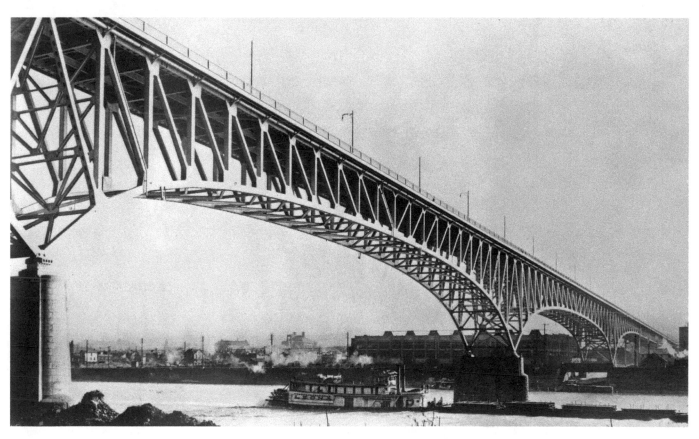

Following the influx of money from New Deal federal programs, many bridges and highways throughout Pennsylvania underwent improvement projects. Seen here in 1939 is one of several updated bridges spanning the Allegheny River in Pittsburgh.

A working family of Polish ethnicity sits on their porch in the town of Mauch Chunk (now Jim Thorpe) in 1940. A center of coal transportation and a significant destination for railroad excursionists in the nineteenth century, Mauch Chunk, as well as many other Pennsylvania mining towns, experienced a difficult economic depression resulting from reductions in coal production following World War II.

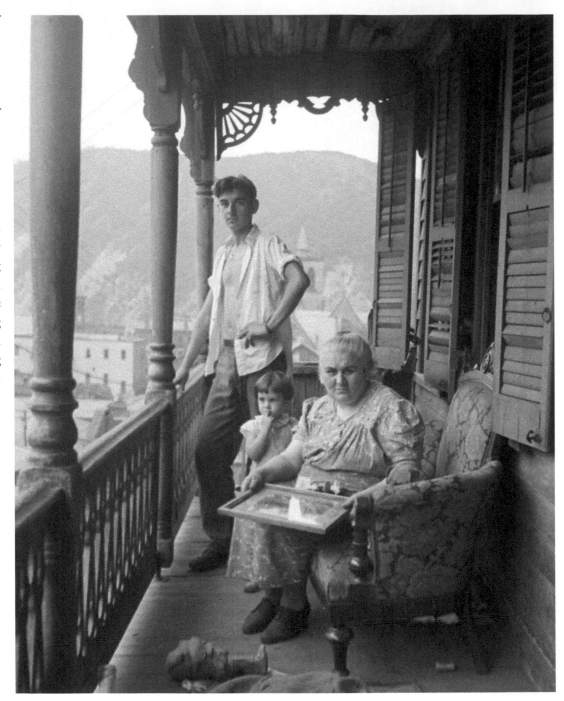

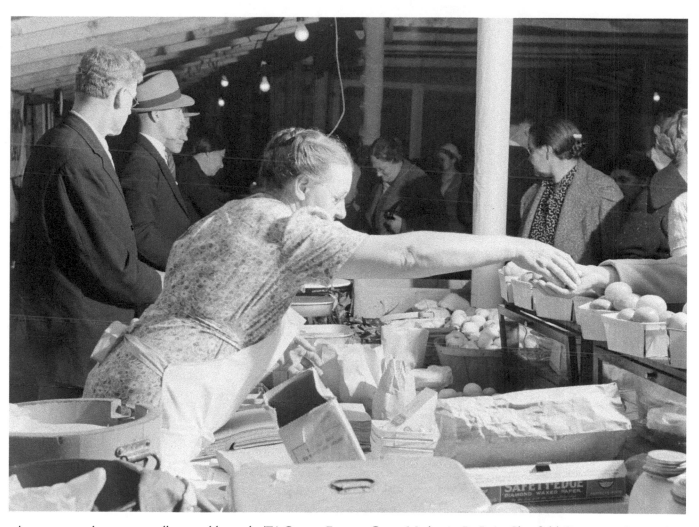

An apron-wearing woman sells vegetables at the Tri-County Farmers Co-op Market in DuBois, Clearfield County, 1940. Markets like this one continue to be staples of the small-farm community throughout the state.

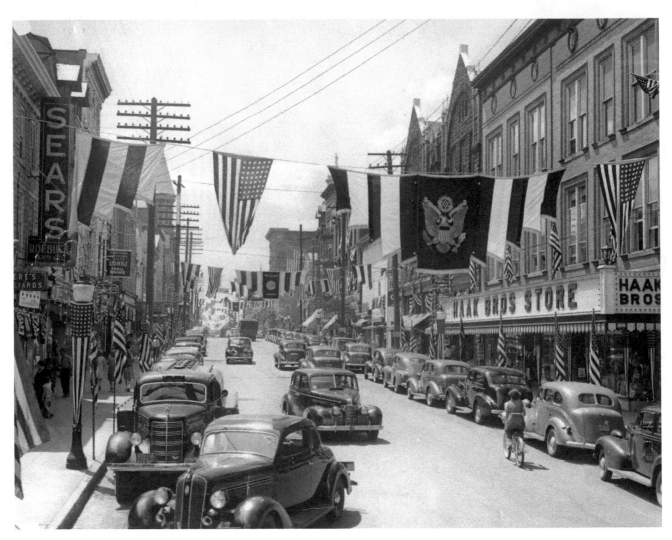

A flag-festooned street in downtown Lebanon as the city celebrates its bicentennial year in 1940.

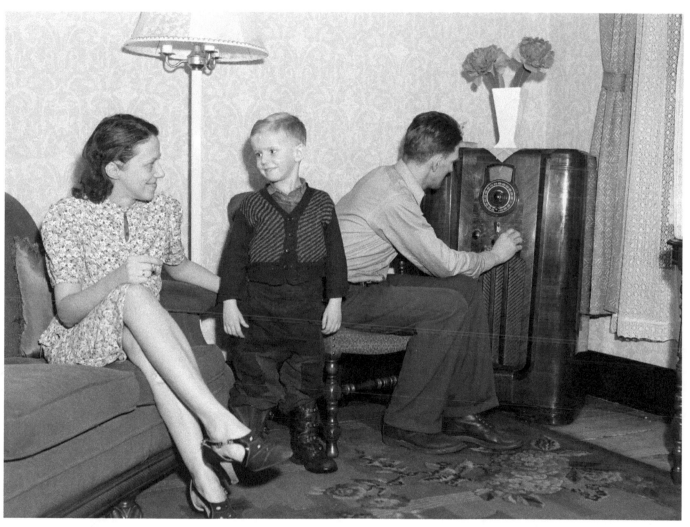

A steelworker and his family in Aliquippa, Beaver County, enjoy time spent listening to the radio in January 1941.

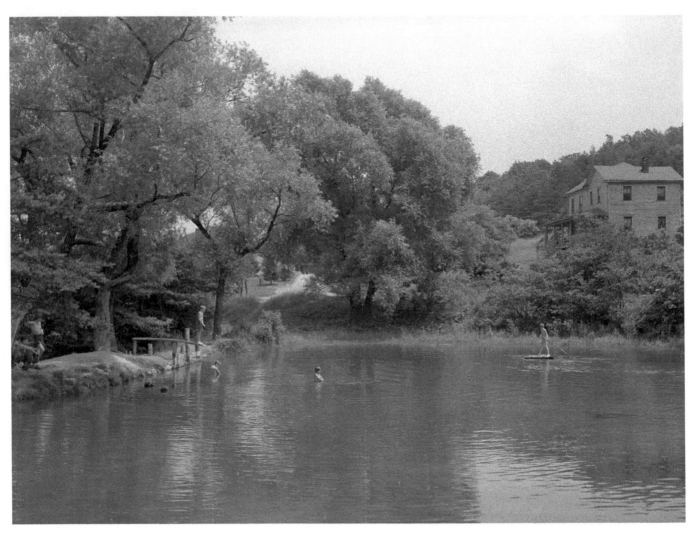

Local children enjoy a swimming hole in Pine Grove Mills, a small town at the center of the state, in July 1941.

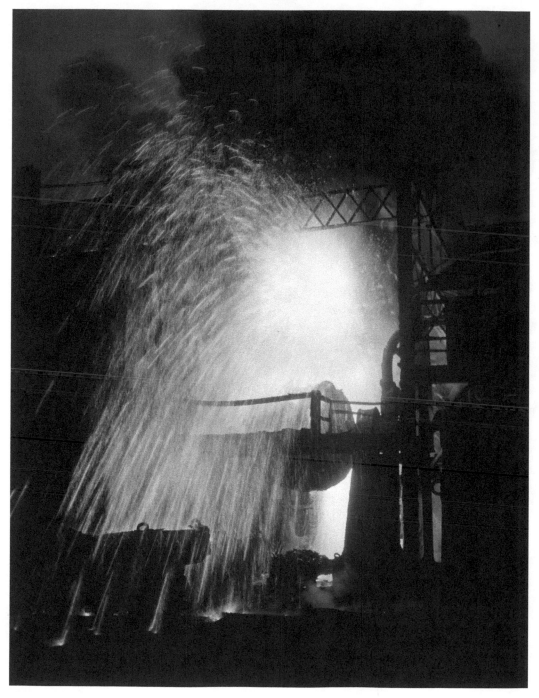

In a dramatic explosion of sparks, iron is purified on its way to becoming stainless steel in a Bessemer converter at the Allegheny Ludlum Steel Corporation factory in Brackenridge, Allegheny County, around 1941.

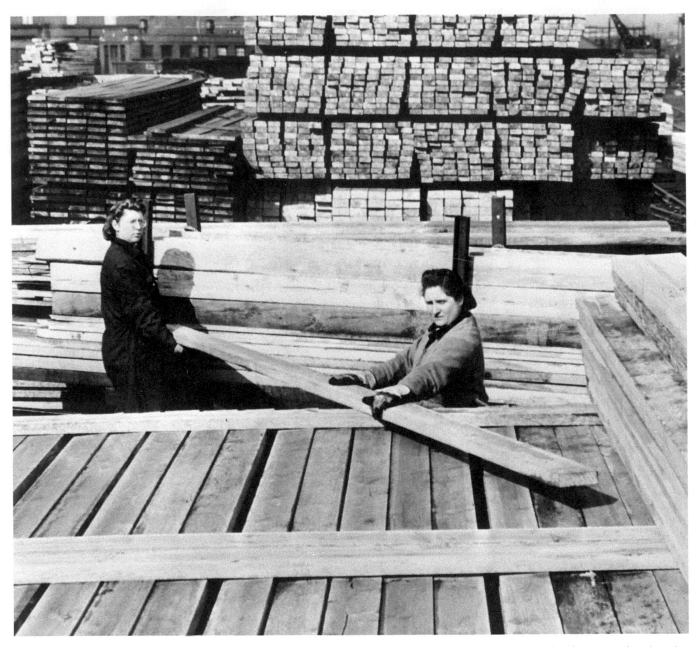

During World War II, women were recruited to work in all levels of industry. Here, two women unload lumber at a railroad yard in Reading.

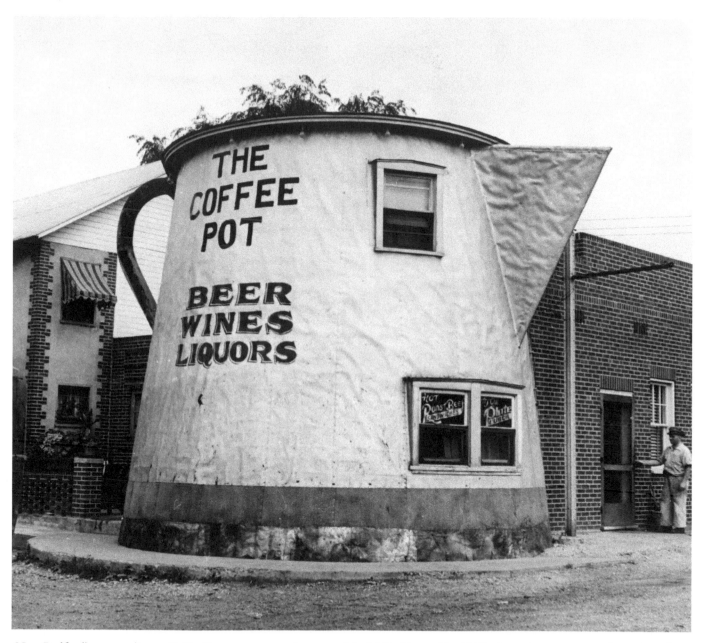

New Bedford's extraordinary Coffee Pot restaurant as it appeared in 1943. Opened in 1927, the unique spot served travelers along the Lincoln Highway (Route 30). Facing demolition in the late 1990s, it was saved by a local preservation group and moved to the nearby Lawrence County fairgrounds in 2004.

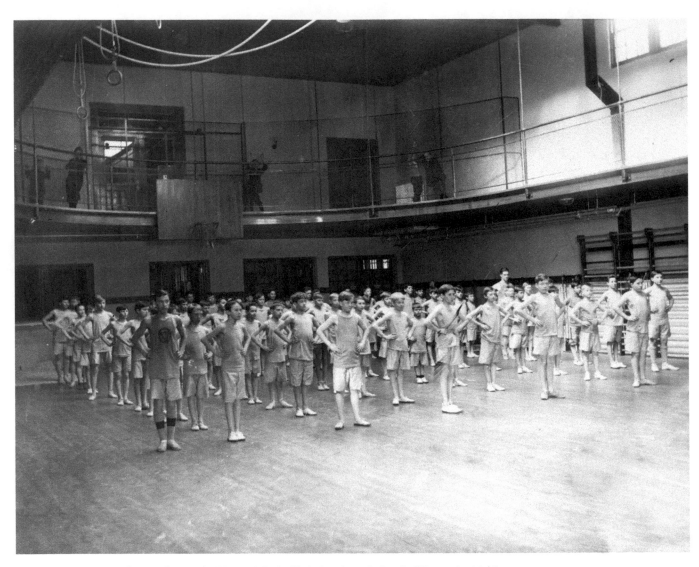

Boys participate in a fitness class at the Young Men's Christian Association in Warren in 1945.

# Strength Through Change

## (1950–1980)

A view east on Hamilton Street in Allentown toward "The Tower," headquarters of Pennsylvania Power and Light, February 23, 1952. Designed by architect Harvey Corbett and completed in 1928, the art-deco structure was a precursor to similar skyscrapers designed by Corbett for New York City, including Rockefeller Center.

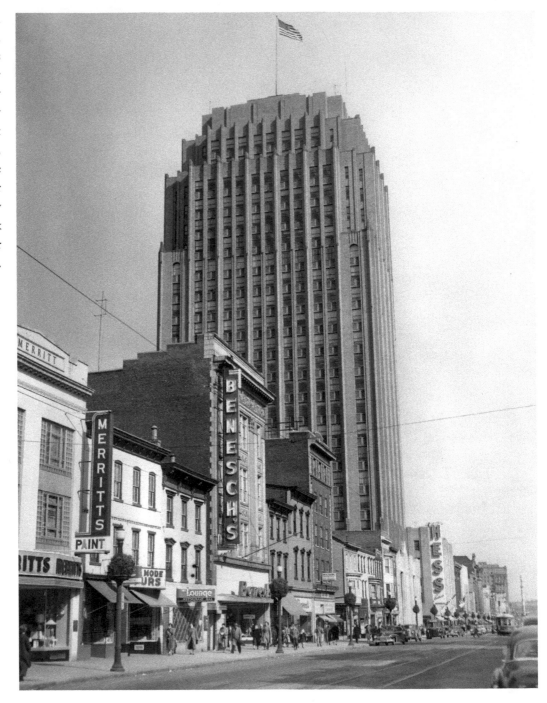

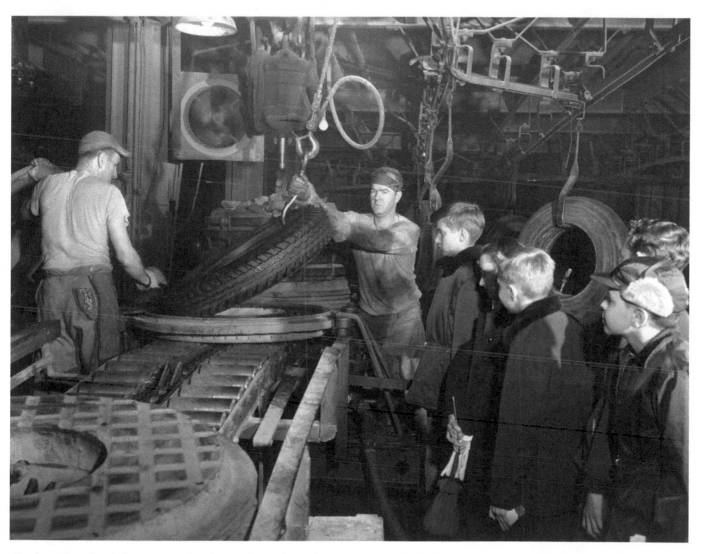

Students from local elementary schools visit the Lee Tire Company in Conshohocken, January 10, 1952. Lee Tires were produced in Conshohocken until 1963; production resumed from 1965 to 1978 under the auspices of Goodyear Tire & Rubber Company.

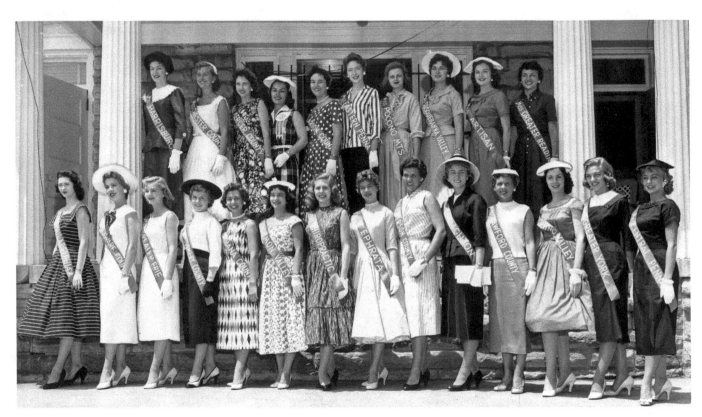

Contestants in the Miss Pennsylvania beauty pageant in 1956, photographed at Longwood Gardens in Kennett Square. Miss Delaware County, Lorna Malcomson Ringler (second from left in the front row), subsequently represented Pennsylvania in the Miss America pageant in Atlantic City.

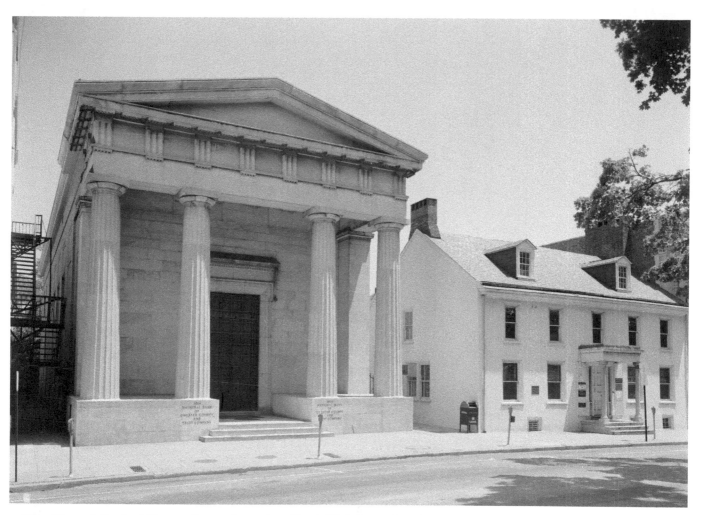

West Chester's Bank of Chester County, located on North High Street. Seen here in June 1958, the 1837 Greek-revival building designed by Thomas Ustick Walter sits at the heart of West Chester's Historic District and remains in use as a bank.

The second home of the Philadelphia Saving Fund Society, at 306 Walnut Street in Philadelphia, as it appeared in 1958. Founded in 1816 and initially located in a building on Sixth Street, the bank charged architect Thomas Ustick Walter with the task of designing and erecting the new building in 1840.

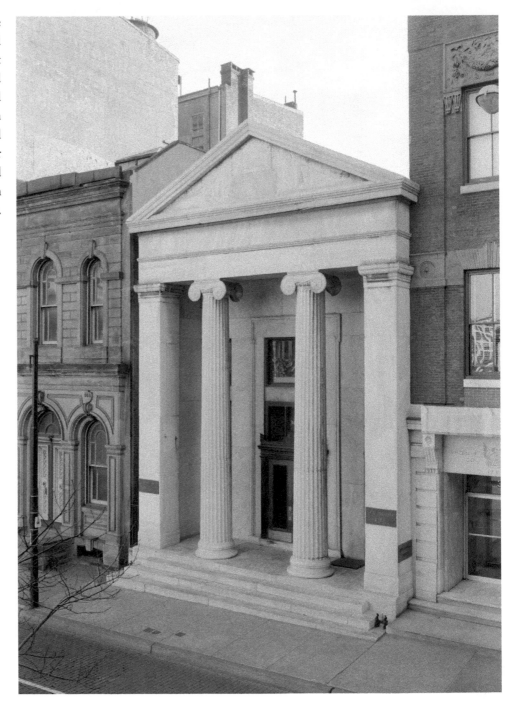

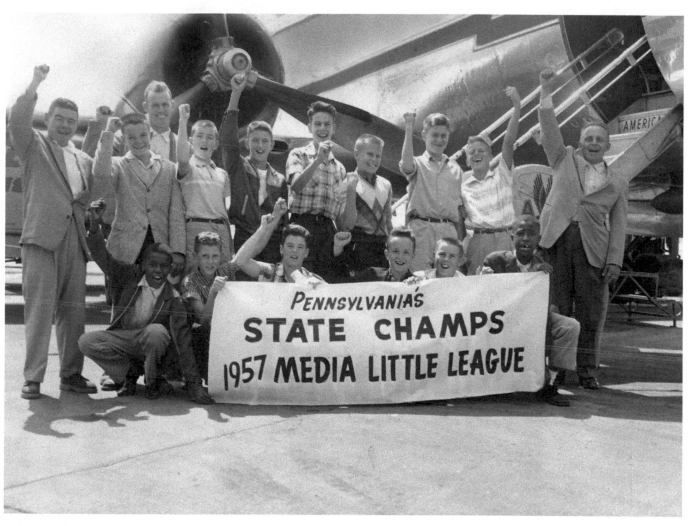

State Little League baseball champions from Media prepare for their flight to New York to compete in the regional contest. They were defeated by the Bridgeport, Connecticut, team, which went on to win the Little League World Series of 1957.

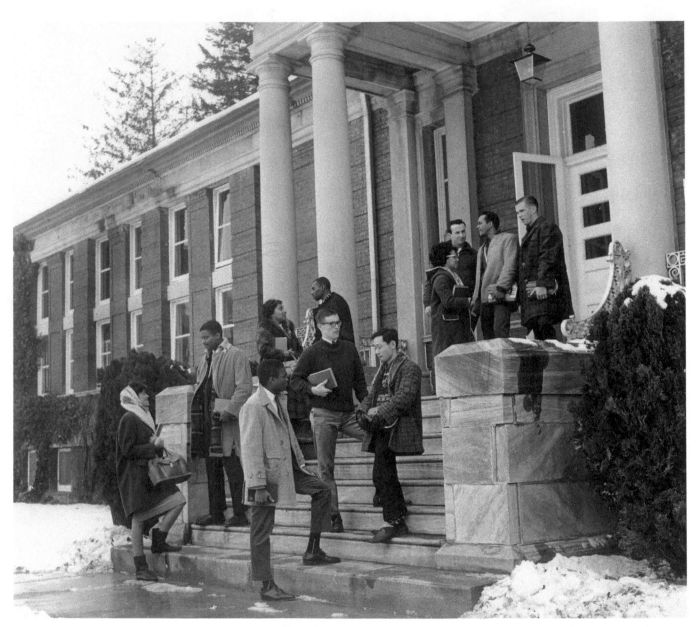

Students at Lincoln University gather on the steps of Vail Hall. Chartered in 1854 for the specific purpose of providing higher education to African American males, the university soon went on to serve an increasingly diverse and international educational community and admitted women for the first time in 1952. Lincoln University includes among its alumni poet Langston Hughes and Supreme Court justice Thurgood Marshall, and today enrolls over 2,000 students.

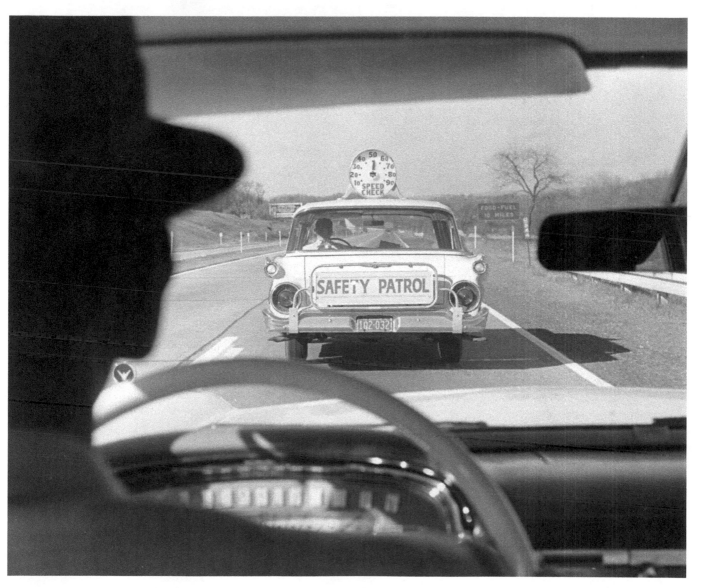

In a temporary effort to emphasize proper speed limits and increase safety along the Pennsylvania Turnpike, an oversized speedometer is placed on a safety patrol car in 1960.

Completed in 1886, the Allegheny County Courthouse features an interior courtyard and is a fine example of Richardson Romanesque design, named after the architect H. H. Richardson.

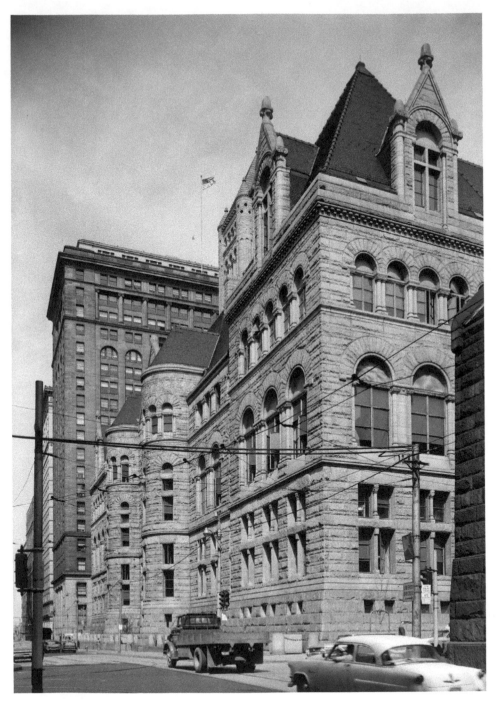

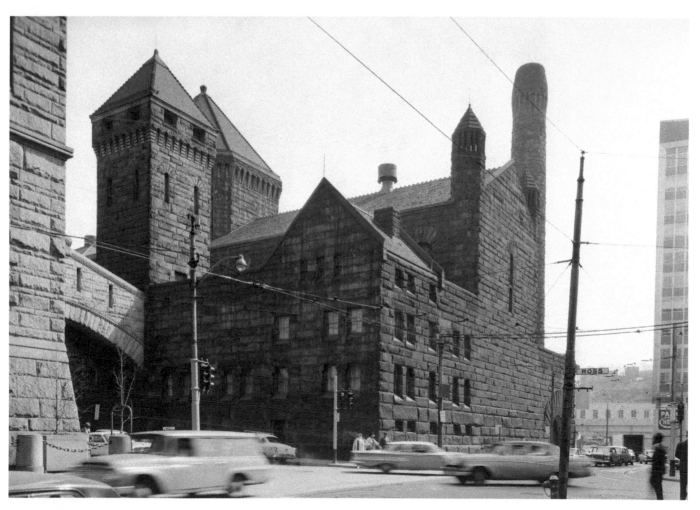

Attached to the Allegheny County Courthouse by a second-story bridge called the "Bridge of Sighs," the old Allegheny County Jail is now used as an extension of the courthouse.

Ice cream appeals to everyone, as expressed in this magical moment when the final product was revealed at the Pennsylvania County Fair in 1965. "Homemade" ice cream was created in hand-cranked contrivances like the one shown here.

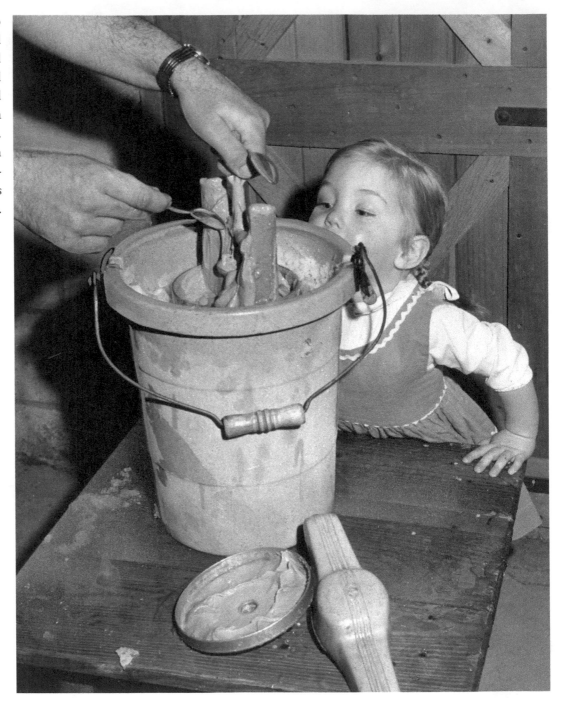

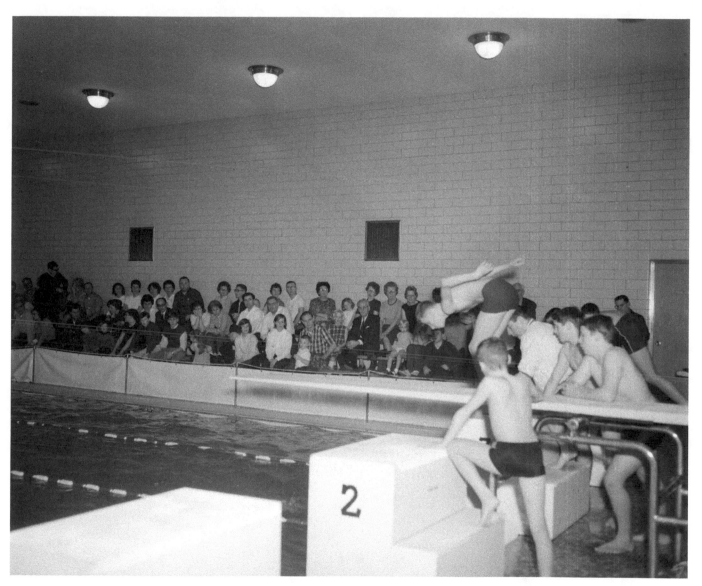

Boys participate in a swimming competition at the local Young Men's Christian Association in Warren County, 1967.

Completed in 1897, Dental Hall at the University of Pennsylvania in Philadelphia was the first "purpose-built" school of dentistry in the United States. Later, it housed the university's School of Architecture.

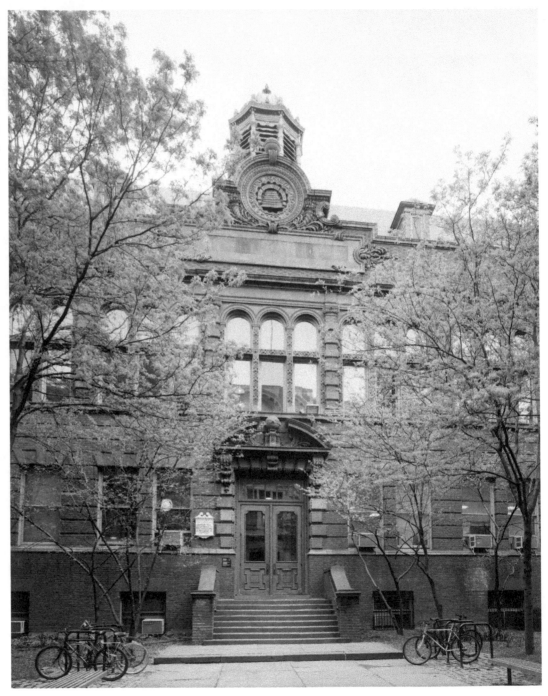

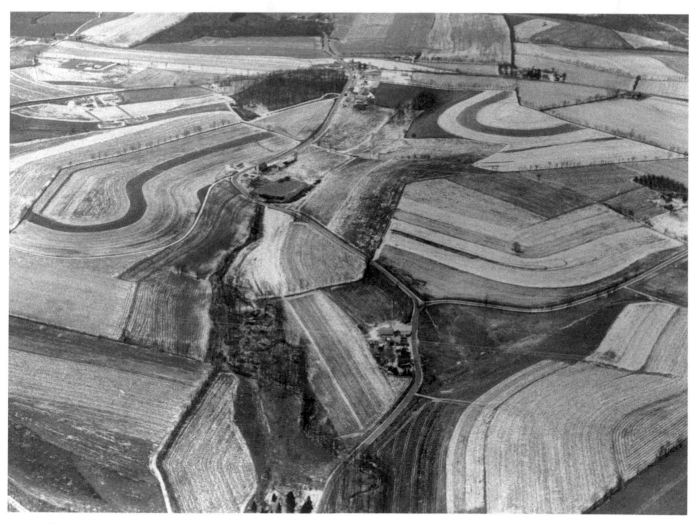

This dramatic aerial view of the farmlands of central Bucks County after a light snowfall in 1974 highlights the significance of agriculture to the county. In the last three decades, the rural landscape in Bucks County has been threatened by increased residential developments, and efforts are ongoing to preserve some of the area's agricultural traditions.

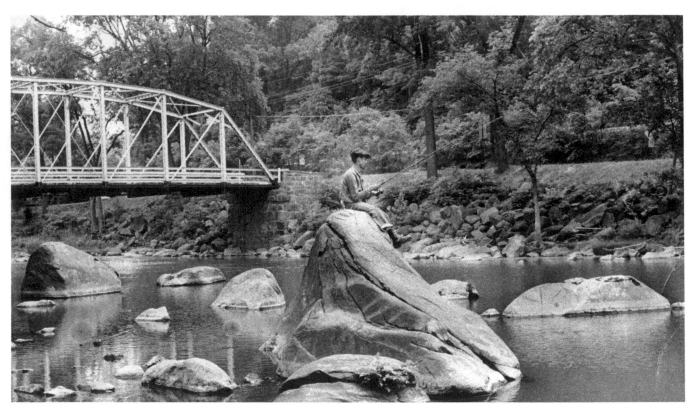

A young man enjoys a quiet moment of fishing along the Perkiomen Creek in Montgomery County, June 1974.

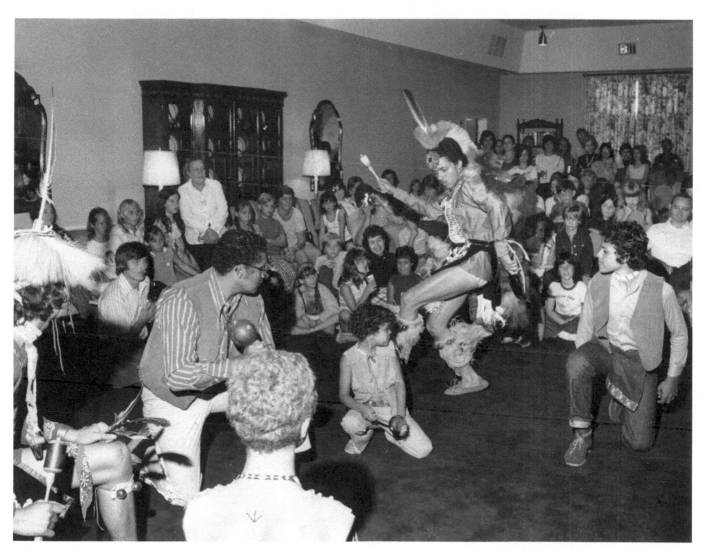

A dancer with the United American Indians of the Delaware Valley performs for schoolchildren in Bensalem, July 22, 1975.

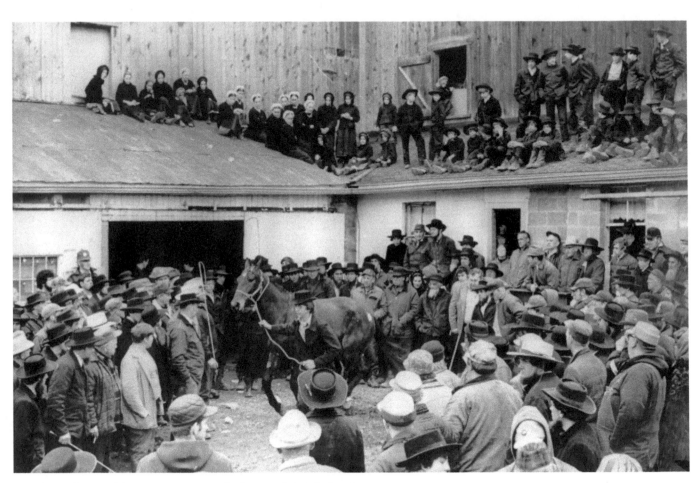

Members of an Amish community attend a horse sale in Madisonburg.

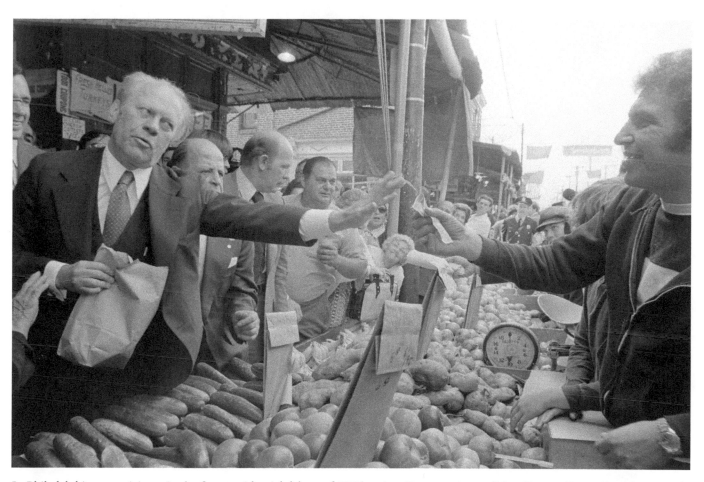

In Philadelphia to participate in the first presidential debate of 1976 against Democratic candidate Jimmy Carter, President Gerald Ford visits the Ninth Street market popularly known as the Italian Market.

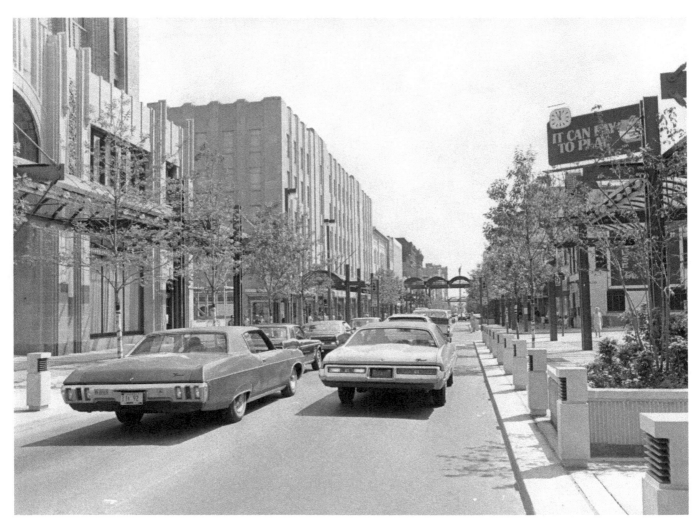

Hamilton Mall in Allentown was created in the mid-1970s in an effort to draw retail business and shoppers to the downtown area. The design featured an innovative canopy (now removed) that ran the length of all four blocks of the mall.

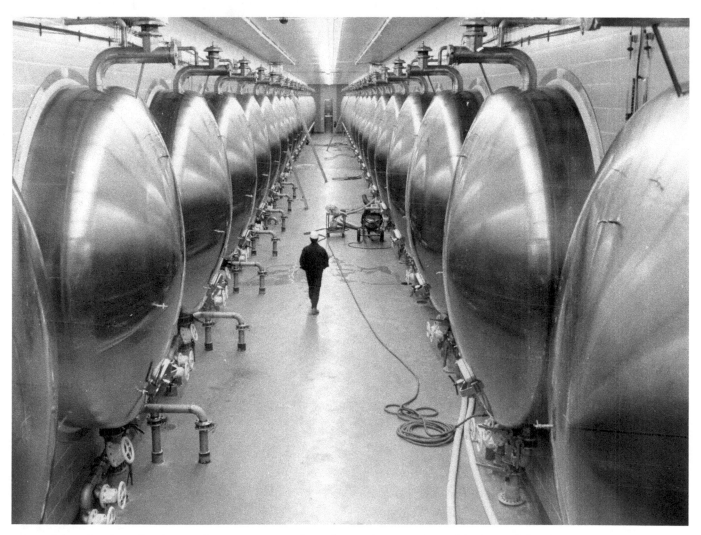

A worker walks along the ultra-modern processing tanks in the new brewery plant of the F&M Schaefer Company in Fogelsville, 1980. Originally based in New York City, Schaefer built the Pennsylvania plant in an effort to compete nationally. It was later bought by the Pabst Brewing Company.

Three months after the worst nuclear-related accident in American history, visitors to the area near the Three Mile Island power plant enjoy a summer excursion in July 1979. While no deaths occurred as a result of the core's overheating, the accident nevertheless resulted in dramatic changes in regulation, planning, and training within the nuclear industry. TMI-2, the tower involved in the accident, remains closed today.

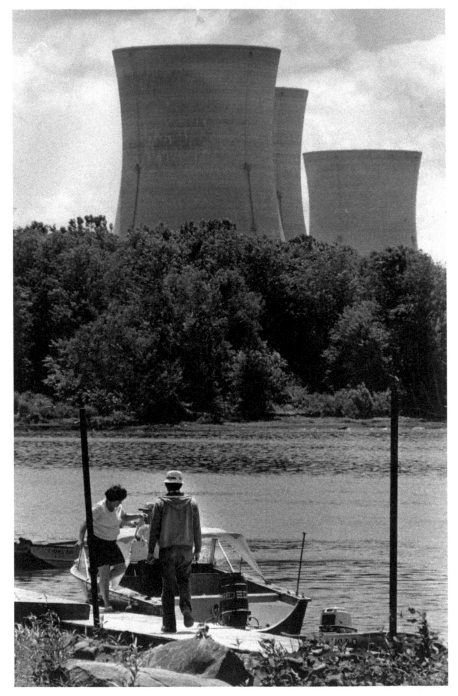

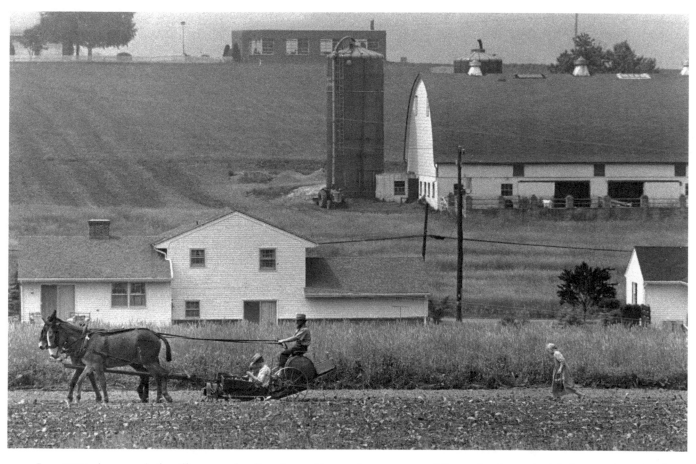

In a 1979 photograph that illustrates the diversity and interesting contrasts of Pennsylvania, an Amish farmer plants his fields using a traditional horse-drawn implement to work his fields near New Holland in full view of modern tract housing.

# Notes on the Photographs

These notes, listed by page number, attempt to include all aspects known of the photographs. Each of the photographs is identified by the page number, photograph's title or description, photographer and collection, archive, and call or box number when applicable. Although every attempt was made to collect all data, in some cases complete data may have been unavailable due to the age and condition of some of the photographs and records.

Printed in the USA
CPSIA information can be obtained
at www.ICGtesting.com
JSHW072022140824
68134JS00042B/3743

9 781683 368717